TREASURES OF THE

LOUVRE

TREASURES OF THE

LOUVRE

Preface by
MICHEL LACLOTTE

A TINY FOLIO™
ABBEVILLE PRESS PUBLISHERS
NEW YORK LONDON PARIS

FRONT COVER: Leonardo da Vinci. Detail of *Mona Lisa*, also called *La Giocanda*, 1503–6. See page 261.

BACK COVER: Hubert Robert (1733–1808). Detail of *Project for the Disposition of the Grande Galerie*, 1796. Canvas, 44 x 56¼ in. (112 x 143 cm).

SPINE: *Vénus de Milo*, c. 100 B.C. See page 93.

EDITORS: Amy Handy and Nancy Grubb
PRODUCTION EDITOR: Alice Gray
PRODUCTION MANAGER: Matthew Pimm

Third edition

15 14 13 12 11 10 9 8 7

Library of Congress Cataloging-in-Publication Data
Laclotte, Michel.
 Treasures of the Louvre / Michel Laclotte.
 p. cm.
 ISBN 0-7892-0406-1
 1. Art–France–Paris–Catalogs. 2. Musée du Louvre–Catalogs.
 I. Musée du Louvre. II. Title.
N2030.A65 1993
708.4'361—dc20 92-38308

Contents

ACKNOWLEDGMENTS

We would like to thank the following people
for their assistance and expertise:

ANNIE CAUBET
Department of Oriental Antiquities

JEAN-LOUIS DE CÉNIVAL
Department of Egyptian Antiquities

ALAIN PASQUIER
*Department of Greek, Roman, and
Etruscan Antiquities*

DANIEL ALCOUFFE
Department of Decorative Arts

JEAN-RENÉ GABORIT
Department of Sculpture

PIERRE ROSENBERG
Department of Paintings

FRANÇOISE VIATTE
Department of Drawings

PREFACE

The doors of the Louvre opened to the public for the very
first time more than two hundred years ago. The Museum
Central des Arts, as it was then called, was established by
the young republic in 1793, though the idea of turning
the palace of the French kings into a museum had already
been considered at the time of the ancien régime. The
majority of paintings, drawings, statues, and decorative art
objects in the "museum of the nation" came from the
royal—by then national—collections.

Since then the museum has progressively spread out
into the different parts of the palace itself and into the
adjoining buildings constructed subsequently, most notably
the Ministry of Finance. Today the Musée du Louvre
stretches over an enormous architectural ensemble run-
ning parallel to the Seine, right in the heart of the city of
Paris and its gardens.

Operation "Grand Louvre," currently underway, is
in the process of literally transforming the museum from
top to bottom. As part of this enormous enterprise, the
palace itself is being restored and thoroughly rearranged,
the magnificent moats surrounding the medieval ramparts

of the fortress have been uncovered, and a vast underground area containing all the indispensable visitor services and technical equipment has been created. This gradual but total metamorphosis of the Louvre has also involved the restoration of the sculpted facades of the courtyards; the installation of a new entrance in the center of the Cour Napoléon, featuring architect I. M. Pei's famous glass pyramid; a new display space for French painting around the Cour Carrée; and the incorporation of the Ministry of Finance into the museum. The display area has been doubled so that in the future the museum's collections can be totally reorganized into a more logical and ample presentation.

This radical program of modernization goes hand in hand with a legitimate respect for the past, a policy apparent not only in the obvious care given to the renovation of the old interior decoration, but also in the design of the new rooms and of the original structures. This regard for the past extends to the traditions of the museum itself as they have evolved over the past two centuries from the museum's formation through the various phases in its development.

The history of the collections begins with the transfer to the Louvre palace of the artistic treasures in the royal collections first assembled by Francis I (1494-1547). During the Revolutionary period this prestigious core was enriched with treasures taken from the nationalized col-

lections of emigrants and churches and by purchase, to which were added, during the Republic and the Empire, the spoils of war in Europe. In 1815, after Waterloo, the victorious allies forced France to restitute all but a few of the paintings and ancient sculptures seized in Italy, the Netherlands, Germany, and Belgium that had been on display at the Louvre in the ephemeral and outstanding "Musée Napoléon."

The collections have been growing ever since. Throughout the nineteenth century, existing departments were methodically enlarged while new sections were opened: the Egyptian Museum was founded by Champollion in 1826, and the Assyrian Museum was formed in 1847. The "primitives," the long-forgotten arts of the Middle Ages, the paintings and decorative arts of the eighteenth century that had been held in contempt during the neoclassic period, and the then-modern art of the nineteenth century are but a few examples of the range of artistic traditions that gradually found their place in the museum.

The Louvre has always endeavored to perfect its representation of the most significant centers and moments in the history of art in Europe, a policy that has been made possible by continual acquisitions and the enlightened and uninterrupted generosity of more than three thousand philanthropists. In this way the encyclopedic ideals that presided over the foundation of the museum

itself in the eighteenth century have been extended and kept alive in the Louvre's comprehensive approach.

The collections today are divided into seven departments. Through a broad range of works and without respect to technical distinctions, the first three departments—Oriental Antiquities; Egyptian Antiquities; and Greek, Etruscan, and Roman Antiquities—illustrate the art and culture of the ancient Near East and Middle East (including Islamic art), and the Mediterranean countries. The other four so-called "modern" departments are based on artistic categories—painting, sculpture, decorative arts, and drawing—and span Western art from the height of the Middle Ages to the mid-nineteenth century.

This book provides a grand tour in miniature of the Louvre's seven departments, highlighting its most renowned masterpieces. Visitors to the museum can thus retain a beautiful visual reminder of what they have seen. Those who have never been to the Louvre will have a tantalizing glimpse of this superb collection, and will perhaps be encouraged to experience the museum in person to become better acquainted with these great works of art.

MICHEL LACLOTTE
Director, Musée du Louvre

ORIENTAL
ANTIQUITIES

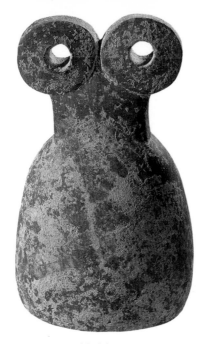

Idol of the Eyes.
Northern Mesopotamia, c. 3300–3000 B.C.
Terra-cotta, 10⅝ in. (27 cm) high.

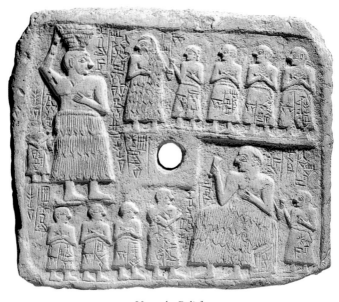

Urnanshe Relief.
Tello, formerly Girsu, c. 2500 B.C.
Limestone, 15⅝ x 18½ in. (40 x 47 cm).

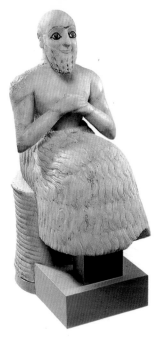

Ebih-Il, Superintendent of Mari. From the Temple of Ishtar.
Mari, Middle Euphrates, c. 2400 B.C.
Alabaster, 20⅝ in. (52 cm) high.

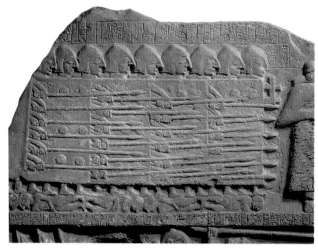

Detail of *Stele of the Vultures*.
Tello, formerly Girsu, c. 2450 B.C.
Limestone, 70⅞ x 51⅝ in. (180 x 130 cm).

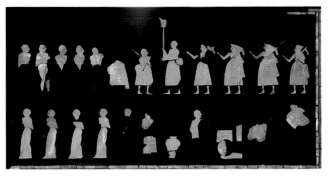

Standard of Mari. From the Temple of Ishtar.
Mari, Middle Euphrates, c. 2400 B.C.
Shell, mosaic, dimensions unknown.

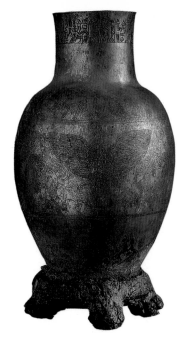

Vase of Entemena, Prince of Lagash.
Tello, formerly Girsu, c. 2400 B.C.
Silver, copper, 13¾ x 7⅛ in. (35 x 18 cm).

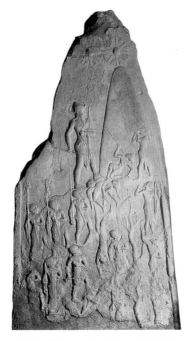

Stele of Naram-Sin, King of Akkad.
Mesopotamia, c. 2250 B.C.
Pink sandstone, 78¾ x 41⅜ in. (200 x 105 cm).

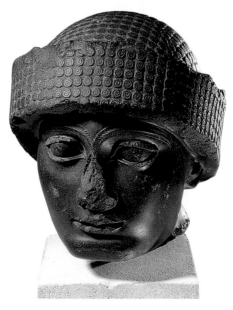

Gudea, Prince of Lagash.
Tello, formerly Girsu, c. 2120 B.C.
Diorite, 9 x 4¾ in. (23 x 11 cm).

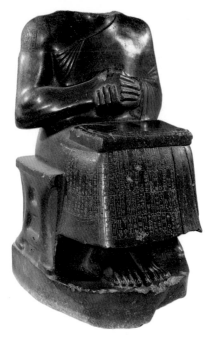

Gudea Holding the Plan of a Building.
Tello, formerly Girsu, c. 2120 B.C.
Diorite, 36⅝ x 16⅛ in. (93 x 41 cm).

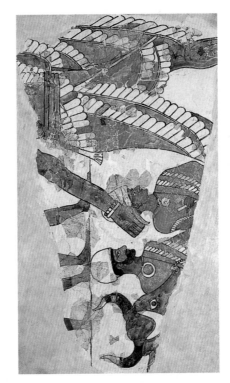

Officiator at the Royal Sacrifice.
Mari, Syria, c. 1800 B.C.
Painted plaster, 29⅞ x 52 in. (76 x 132 cm).

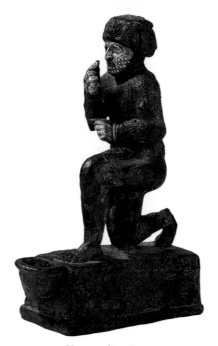

Hammurabi at Prayer.
Larsa, Iraq, c. 1760 B.C.
Bronze, gold, 7⅝ x 5⅞ in. (19 x 15 cm).

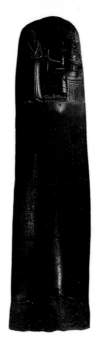

Law Code of Hammurabi, King of Babylon.
Susa, Mesopotamia, 18th century B.C.
Basalt, 88⅝ in. (225 cm) high.

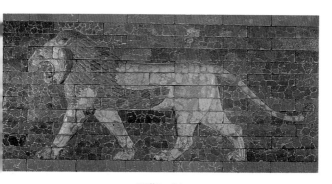

Walking Lion.
From the Temple of Ishtar. Babylon, 6th century B.C.
Glazed brick, 41⅜ x 85⅜ in. (105 x 217 cm).

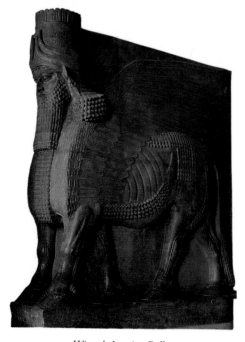

Winged Assyrian Bull.
From the Palace of Sargon II. Khorsabad, 713–705 B.C.
Gypsum, 13 ft. 9⅜ in. x 14 ft. 3⅝ in. (4.2 x 4.36 m).

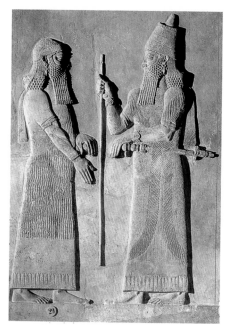

Sargon and a Dignitary.
From the Palace of Sargon II. Khorsabad, 713–705 B.C.
Gypsum, 117⅜ x 48 in. (298 x 122 cm).

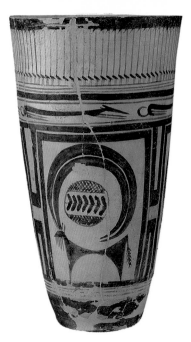

Goblet. Susa, c. 4000 B.C.
Painted terra-cotta,
22¾ in. (58 cm) high x 6¼ in. (16 cm) diam.

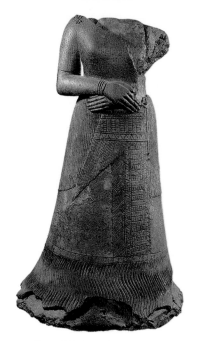

Queen Napirasu. Susa, 1350 B.C.
Bronze, 50¾ x 28¾ in. (129 x 73 cm).

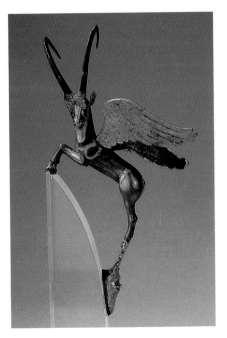

Vase Handle.
Iran, Achaemenid Period, 5th century B.C.
Silver, gold, 10⅝ x 5⅞ in. (27 x 15 cm).

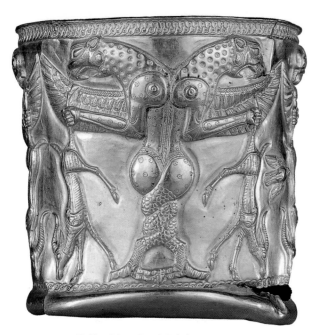

Goblet Adorned with Fabulous Monsters.
Marlike civilization, northern Iran,
13th–12th century B.C. Electrum, 4⅜ in. (11 cm) high.

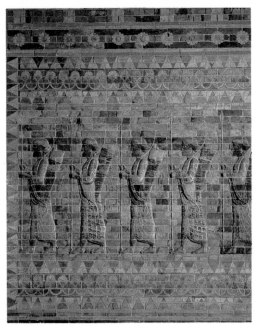

The Archers of Darius.
Susa, c. 500 B.C.
Glazed brick, 78¾ in. (200 cm) high.

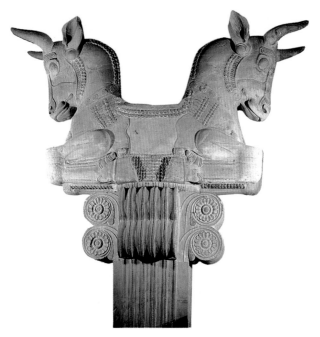

Capital of a Column of Apadana.
Susa, c. 600 B.C.
Limestone, 126 in. (320 cm) high.

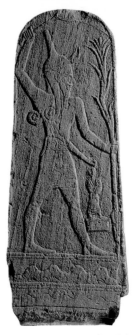

Stele of Baal with a Thunderbolt.
Ras Shamra, ancient Ugarit, 14th century B.C.
Sandstone, 55⅞ in. (142 cm) high.

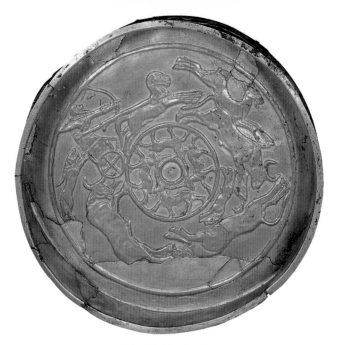

Plate with Hunting Scene.
Ras Shamra, ancient Ugarit, 14th century B.C.
Gold, 7¼ in. (18 cm) diam. x 1¼ in. (3 cm) high.

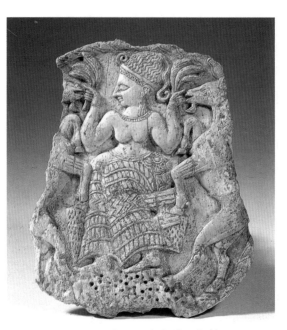

Cosmetic-Box Cover with Fertility Goddess.
Ancient Ugarit, 13th century B.C.
Ivory, 5⅜ in. (13.7 cm) high.

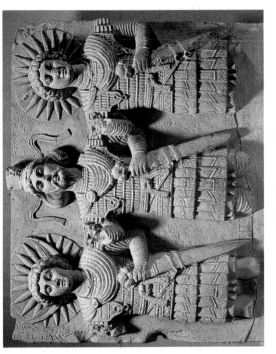

Triad of Palmyrean Gods.
Palmyra region, c. 150 A.D.
Limestone, 28 in. (71 cm) high.

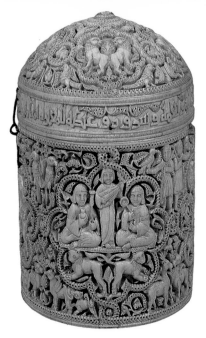

Pyxis of Al-Mughira.
Cordoba, Spain, 968.
Ivory, 6⅞ x 4⅜ in. (17.6 x 11.3 cm).

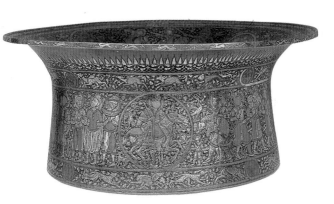

Basin, called *The Baptistery of Saint Louis.* Syria or Egypt,
late 13th or early 14th century.
Engraved brass inlaid with gold, silver, and copper,
9⅛ in. (23.2 cm) high x 19⅞ in. (50.5 cm) diam.

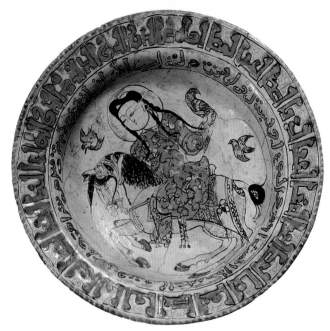

Cup with Falconer on Horseback.
Iran, late 12th or early 13th century. Siliceous ceramics with
overglaze embellished in gold and metallic lusters,
2⅝ in. (6.5 cm) high x 8⅝ in. (22 cm) diam.

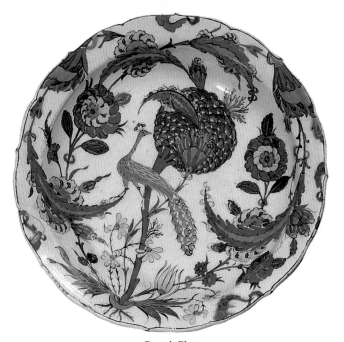

Peacock Plate.
Iznik, Turkey, 2d quarter of 16th century.
Siliceous ceramics with underglaze decoration,
3⅛ in. (8 cm) high x 14¾ in. (37.5 cm) diam.

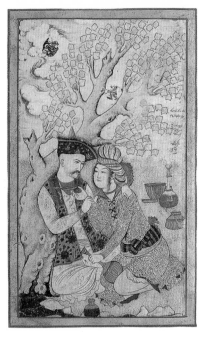

Shah Abbas I.
Isfahan, Iran, March 12, 1627. Ink, color, and gold leaf
on paper, 10¾ x 6⅝ in. (27.5 x 16.8 cm).

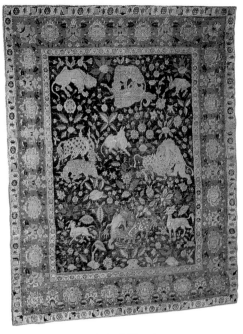

Animal Carpet.
Kachan, Iran, 16th century.
Asymmetrically knotted silk, 48¾ x 42⅞ in. (124 x 109 cm).

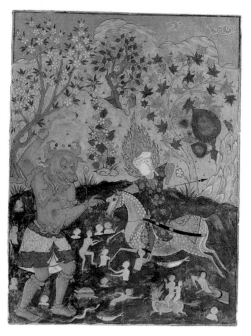

Rider Fighting a Daeva. Tabriz or Qazvin, Iran, c. 1550.
Page from *Falnama* (*The Book of Omens*),
23⅝ x 21⅝ in. (59 x 54 cm).

EGYPTIAN ANTIQUITIES

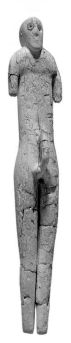

Statuette of a Man, c. 4000–3500 B.C.
Hippopotamus tooth, 9⅜ in. (24 cm) high.

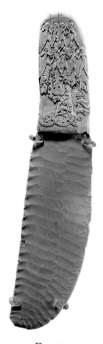

Dagger.
Probably from Guebel-el-Arak, c. 3300–3200 B.C.
Handle of hippopotamus tooth. Handle: 17¾ in. (45 cm) high.

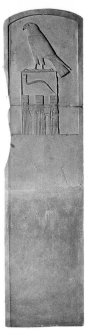

Stele of Djet, Serpent King.
From the tomb of the Serpent King at Abydos.
Thinit period, c. 3100 B.C. Limestone, 25¾ in. (65.5 cm) high.

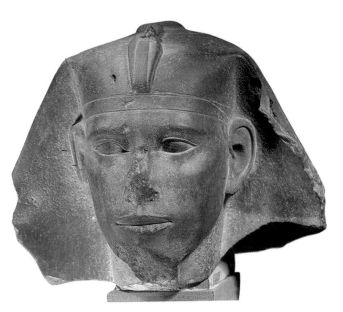

King Didoufri.
Abu Roach, c. 2570 B.C. (4th dynasty).
Red sandstone, 10¼ in. (26 cm) high.

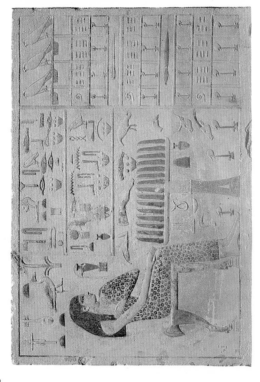

Stele of Nefertiabet.
Giza, Old Kingdom, c. 2590 B.C. (4th dynasty).
Painted limestone, 20⅝ in. (52.5 cm) long.

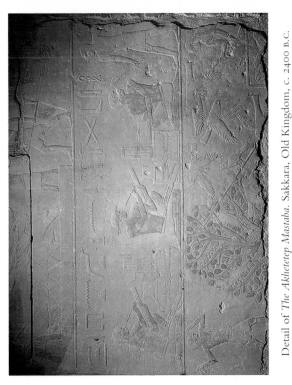

Detail of *The Akhetetep Mastaba*, Sakkara, Old Kingdom, c. 2400 B.C. (5th dynasty). Above: *Scribes Recording the Reopening of the Farms.* Below: *Hunting Scene with Net.* Painted limestone, 14 ft. (4.25 m) long.

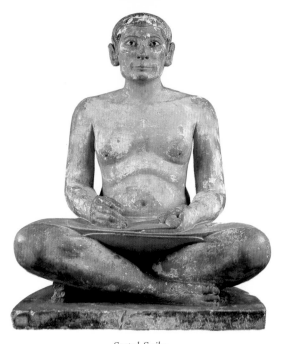

Seated Scribe.
Sakkara, Old Kingdom, c. 2620–2350 B.C. (4th or 5th dynasty).
Limestone, alabaster, rock crystal, 21⅛ in. (53.7 cm) high.

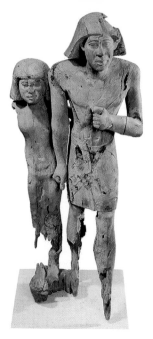

Couple, c. 2350-2200 B.C. (6th dynasty).
Acacia wood, 27⅛ in. (69.9 cm) high.

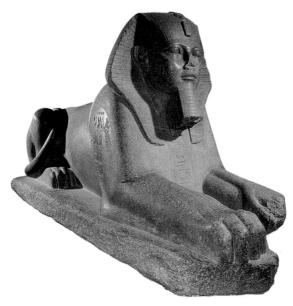

Large Sphinx. Tanis, reign of Amenemhet II (?),
c. 1929–1895 B.C. (12th dynasty).
Pink granite, 15 ft. 9 in. (4.8 m) long.

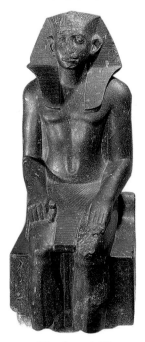

King Sesostris III.
Medamoud, c. 1870–1843 B.C. (12th dynasty).
Diorite, 46⅞ in. (119 cm) high.

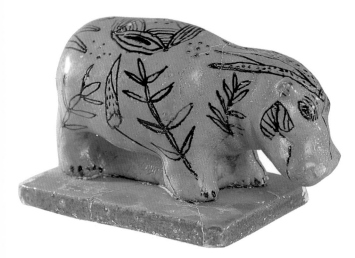

Hippopotamus, c. 2000–1900 B.C. (early 12th dynasty).
Egyptian faïence, 8⅛ in. (20.5 cm) long.

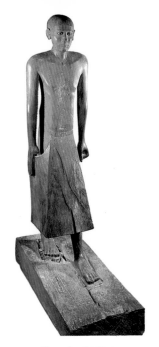

Chancellor Nakhti.
Assiout, c. 2000–1900 B.C. (early 12th dynasty).
Acacia wood, 70⅜ x 43⅜ x 19½ in. (178.5 x 110 x 49.5 cm).

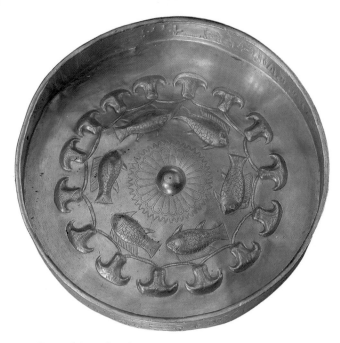

Patera of General Djehuty, c. 1490–1439 B.C. (18th dynasty).
Gold, 7 in. (17.9 cm) diam.

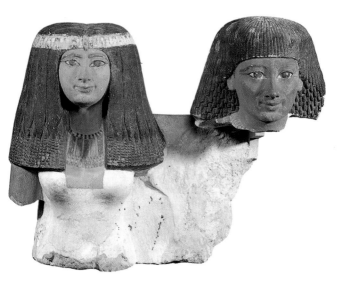

Senynefer and Hatshepsut, c. 1410 B.C. (18th dynasty).
Painted sandstone, 24⅜ x 32⅜ in. (62 x 82 cm).

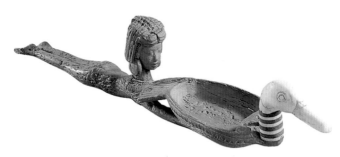

Cosmetic Spoon with a Young Woman Holding a Duck,
c. 1365–1349 B.C. (18th dynasty).
Wood, ivory, 12¾ in. (32.5 cm) long.

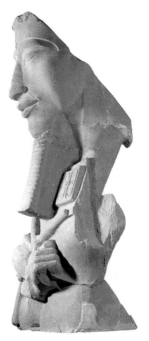

Colossus of Amenhotep IV/Akhenaton,
c. 1365–1349 B.C. (18th dynasty).
Painted sandstone, 54 in. (137 cm) high.

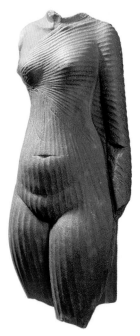

Torso of a Woman, Probably Nefertiti.
Reign of Amenhotep IV/Akhenaton, c. 1365–1349 B.C.
(18th dynasty). Crystallized red sandstone, 11⅞ in. (29 cm) high.

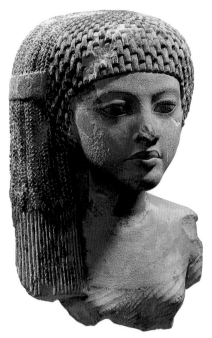

Head of a Princess. Reign of Amenhotep IV/Akhenaton,
c. 1365–1349 B.C. (18th dynasty).
Painted limestone, 6⅛ in. (15.4 cm) high.

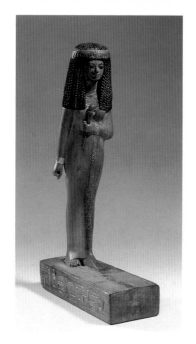

Nay, c. 1400 B.C. (18th dynasty).
Conifer wood plated with gold, 12¼ in. (31 cm) high.

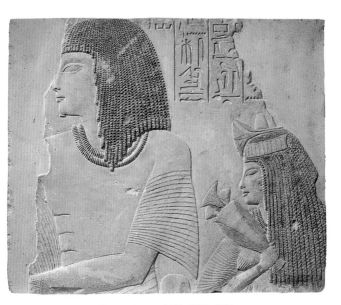

Imeneminet and His Wife, Takha,
c. 1340 B.C. (18th dynasty).
Painted limestone, 22 in. (56 cm) high.

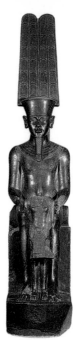

The God Amon and King Tutankhamen,
c. 1347–1337 B.C. (18th dynasty).
Diorite, 84¼ in. (214 cm) high.

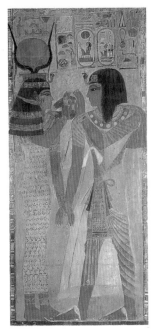

The Goddess Hathor and King Seti I. From the tomb of Seti I.
Valley of the Kings, c. 1303–1290 B.C. (19th dynasty).
Painted limestone, 89⅛ in. (226.5 cm) high.

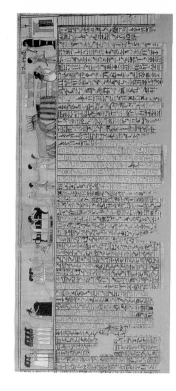

Detail of *The Book of the Dead of Nebqued*. c. 1300 B.C. (18th dynasty). Painted papyrus, 11¾ in. (30 cm) high.

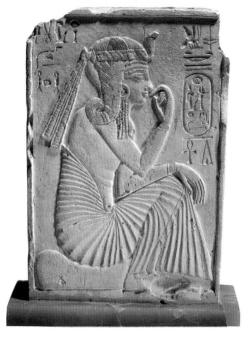

Ramses II as a Child,
c. 1290–1224 B.C. (19th dynasty).
Limestone, 7 in. (18 cm) high.

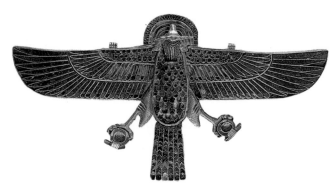

Breastplate in the Shape of a Bird with a Ram's Head,
c. 1290–1224 B.C. (19th dynasty).
Gold, semiprecious stones, 5⅜ x 6⅛ in. (13.5 x 15.7 cm).

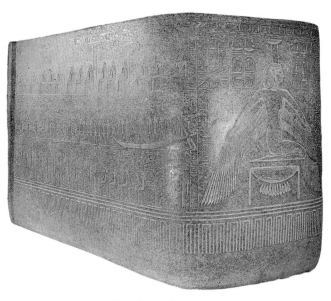

Sarcophagus of Ramses III.
New Kingdom, c. 1196-1162 B.C. (20th dynasty).
Rose granite, 70⅞ in. (180 cm) high.

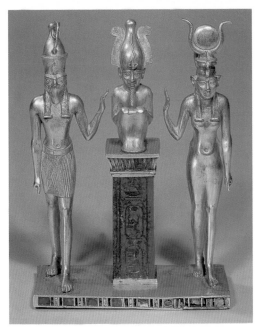

Triad of Osorkon, c. 889–866 B.C. (22d dynasty).
Gold, lapis lazuli, glass, 3⅛ in. (9 cm) high.

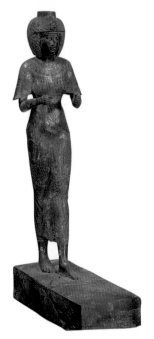

The Divine Worshiper, Karomama, c. 870–825 B.C. (22d dynasty).
Bronze inlaid with gold, silver, and electrum,
23⅜ x 44⅜ x 13¾ in. (59.5 x 112.5 x 35 cm).

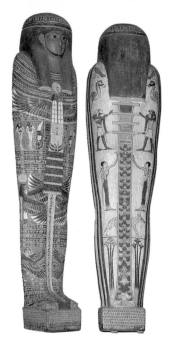

Sarcophagus of Imeneminet, c. 800 B.C. (22d dynasty).
Various materials, plastered and painted, 74 in. (188 cm) high.

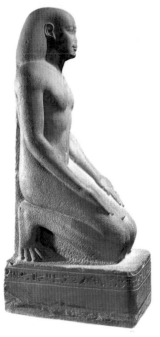

Nakhthorheb, 595–589 B.C. (26th dynasty).
Crystallized sandstone, 58¼ in. (148 cm) high.

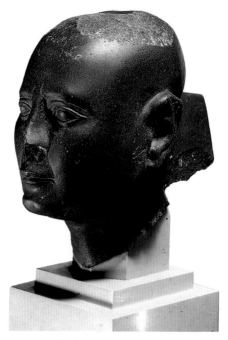

Man with Shaved Head, 4th century B.C.
Schist, 5⅛ in. (12.9 cm) high.

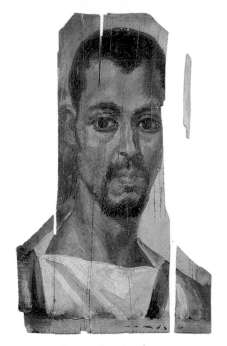

Fayoum Funerary Portrait, 2d century B.C.
Encaustic on wood, 15 x 9⅜ in. (38 x 24 cm).

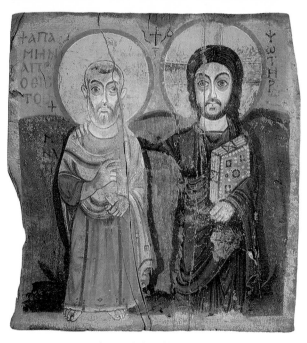

Christ and the Abbot Mena.
Monastery of Baouît, 6th–7th century A.D.
Distemper painting on fig wood, 22⅜ x 22⅜ in. (57 x 57 cm).

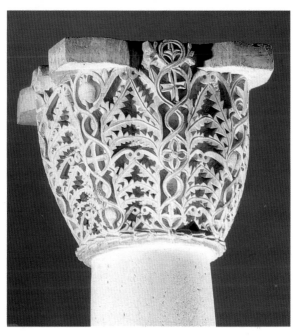

Capital. Monastery of Baouît, 7th–8th century A.D.
Limestone, 21¼ in. (54 cm) high.

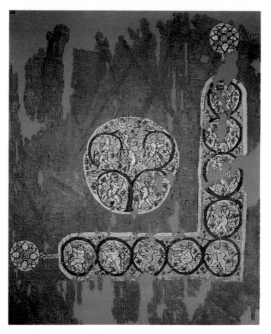

Detail of *Cloth with Cupids Harvesting Wine,* 3d-4th century A.D.
Wool and linen tapestry, 38⅛ x 63¾ in. (97 x 162 cm).

GREEK, ETRUSCAN, AND ROMAN ANTIQUITIES

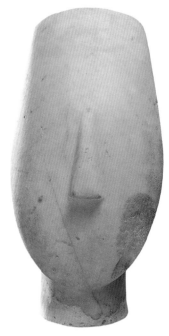

Female Head.
Early Cycladic II, c. 2700–2400 B.C.
Marble, 10⅝ in. (27 cm) high.

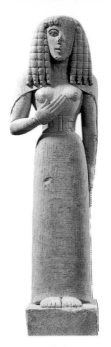

Female Statue, called *La Dame d'Auxerre.*
Cretan Daedalic style, c. 630 B.C.
Limestone, 29½ in. (75 cm) high.

Kore of Samos.
Samos, c. 570 B.C.
Marble, 75⅝ in. (192 cm) high.

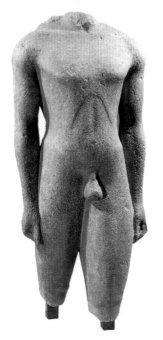

Torso of Kouros.
Naxos style, c. 560 B.C.
Marble, 39⅜ in. (100 cm) high.

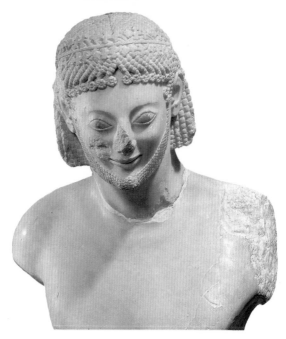

Head of a Horseman, called *The Rampin Rider.* Athens, c. 550 B.C. Marble, 10⅝ in. (27 cm) high.

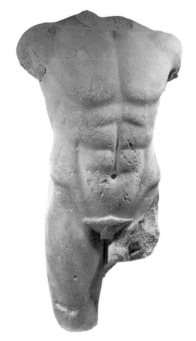

Male Torso, called *The Torso of Miletus*. Miletus,
c. 480 B.C. Marble, 52 in. (132 cm) high.

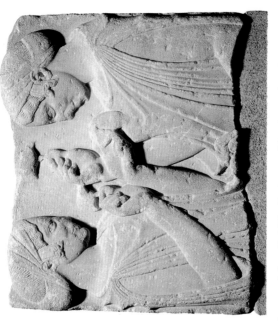

Funerary Stele, called The Exaltation of the Flower. Pharsalus, c. 460 B.C. Marble, 23⅝ in. (60 cm) high.

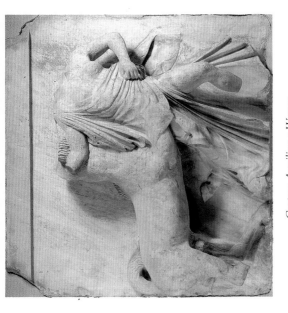

Centaur Assailing a Woman.
Metope from the Parthenon, Athens, 447–440 B.C.
Marble, 53⅛ x 55½ in. (135 x 141 cm).

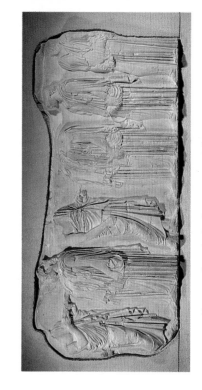

Fragment from the Parthenon Frieze. Athens, c. 440 B.C. Marble, 37¾ x 81½ in. (96 x 207 cm).

Aphrodite. Roman copy of *The Aphrodite of Cnidus*
(original attributed to Praxiteles),
c. 350 B.C. Marble, 48 in. (122 cm) high.

Aphrodite, called *The Kauffmann Head.*
Tralles, 2d century B.C.
Marble, 13⅞ in. (35 cm) high.

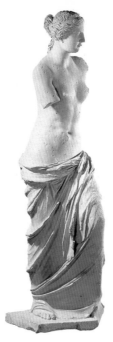

Aphrodite, called *Venus de Milo.* Melos, c. 100 B.C.
Marble, 79½ in. (202 cm) high.

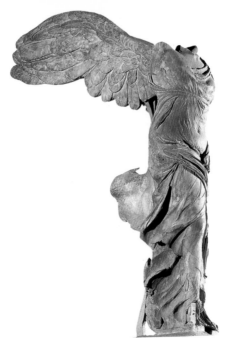

The Winged Victory of Samothrace, c. 190 B.C.
Marble, limestone, 10 ft. 9⅛ in. (3.28 m) high.

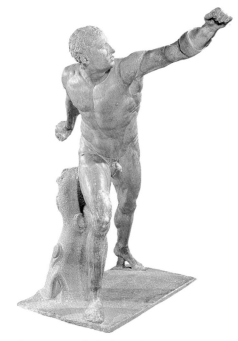

Battling Warrior, called *The Borghese Gladiator.*
Antium, Hellenistic style, early 1st century B.C.
Marble, 78⅜ in. (199 cm) high.

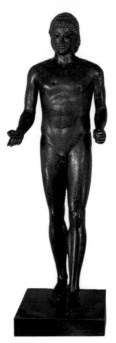

Piombino Apollo. Greater Greece, 1st century B.C.
Bronze, 45¼ in. (115 cm) high.

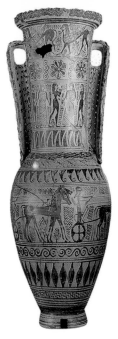

Loutrophoros. Proto–Attic style, c. 680 B.C.
Terra-cotta, 31⅞ in. (81 cm) high.

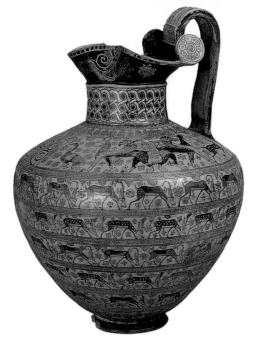

Oenochoe, called *The Levy Oenochoe*.
East Greece, 650 B.C.
Terra-cotta, 15½ in. (39.5 cm) high.

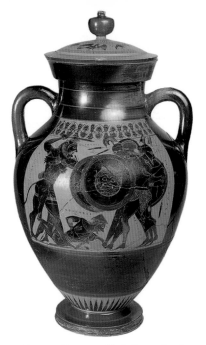

EXEKIAS POTTER. *Black-Figure Amphora.*
Attica, c. 540 B.C.
Terra-cotta, 19⅝ in. (50 cm) high.

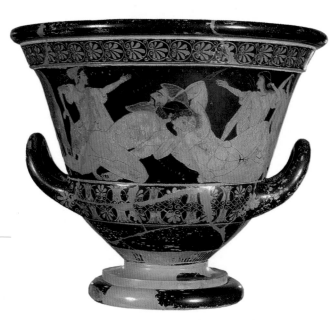

EUPHRONIOS THE PAINTER. *Red-Figure Amphora.*
Attica, c. 510 B.C.
Terra-cotta, 18⅛ in. (46 cm) high.

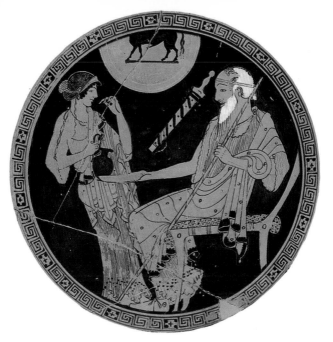

BRYGOS THE POTTER. *Red-Figure Cup: Phoenix and Briseis.*
Attica, c. 490 B.C.
Terra-cotta, 12¼ in. (31 cm) diam.

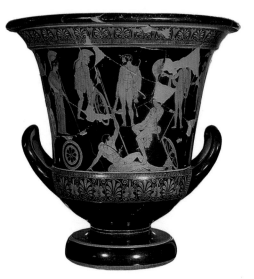

PAINTER OF THE NIOBIDES. *Red-Figure Footed Krater.*
Attica, c. 460 B.C.
Terra-cotta, 21¼ in. (54 cm) high.

Pendant, Head of Acheleous, early 5th century B.C.
Gold, 1⅝ in. (4 cm) high.

Sarcophagus of a Married Couple.
Caere, late 6th century B.C.
Terra-cotta, 44⅞ x 74¾ in. (114 x 190 cm).

Decorative Panels.
Caere, last quarter of 6th century B.C.
Painted terra-cotta, 48⅜ in. (123 cm) high.

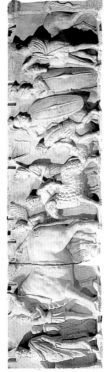

Altar of Domitius Ahenobarbus.
Rome, c. A.D. 100.
Marble, 80⅝ in. (205 cm) long.

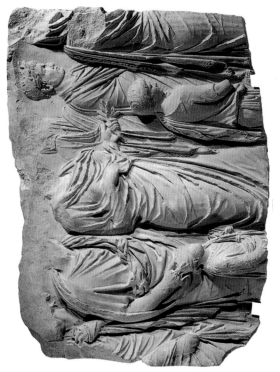

Ara Pacis: Imperial Procession, dedicated 9 B.C. Marble, 47¼ x 57⅞ in. (120 x 147 cm).

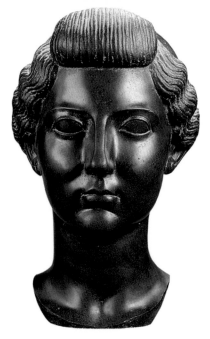

Livia, c. 100 B.C.
Basalt, 13⅜ in. (34 cm) high.

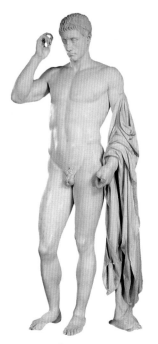

Marcellus. Rome, 23 B.C.
Marble, 70⅞ in. (180 cm) high.

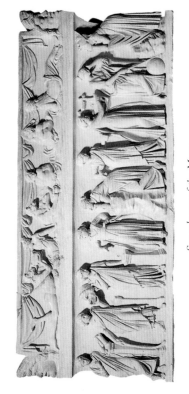

Sarcophagus of the Muses.
Roman region, c. A.D. 150–60.
Marble, 23⅝ x 81⅛ in. (60 x 206 cm).

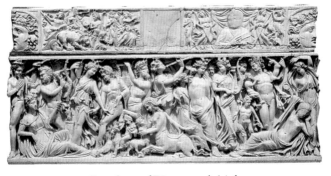

Sarcophagus of Dionysus and Ariadne.
Rome, c. A.D. 235.
Marble, 38⅝ x 81⅞ in. (98 x 208 cm).

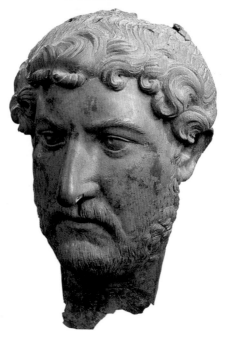

Hadrian, 2d quarter of 2d century A.D.
Bronze, 16⅞ in. (43 cm) high.

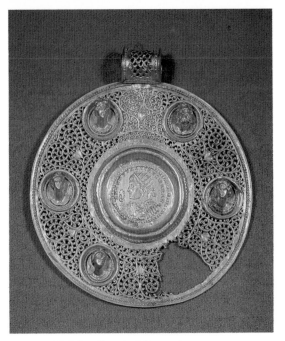

Medallion Portrait of Constantine, A.D. 321.
Gold coin minted at Sirmium, 3⅝ in. (9.2 cm) diam.

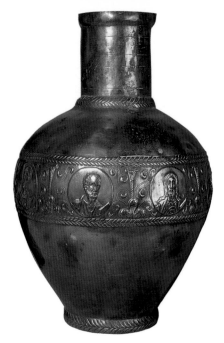

Vase, Emesa (Homs), 6th-7th century A.D.
Silver, 17⅜ in. (44 cm) high.

Diptych of the Muses, 5th century A.D.
Ivory, 11⅜ in. (29 cm) high.

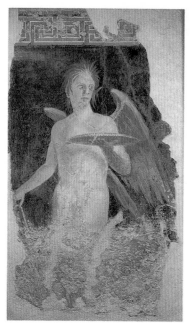

Winged Spirit, 3d quarter of 1st century B.C.
From the villa of Publius Fannius Sinistor, Pompeii.
Painted mural, 49⅝ x 28 in. (126 x 71 cm).

Melpomene, A.D. 62–79.
From the villa of Julia Felix, Pompeii.
Painted mural, 18⅛ in. (46 cm) high.

The Judgment of Paris.
Antioch, c. A.D. 115. Marble, limestone, and glass–paste mosaic,
73¼ in. (186 cm) high.

Phoenix. Daphne, late 5th century A.D.
Marble and limestone mosaic,
19 ft. 8¼ in. x 13 ft. 11⅜ in. (6 x 4.25 m).

DECORATIVE ARTS

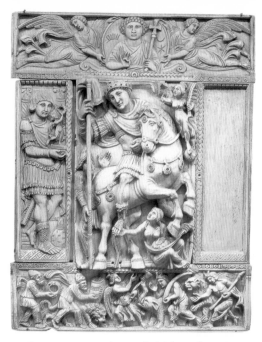

The Emperor Triumphant, called *The Barberini Ivory.*
Constantinople, 1st half of 6th century.
Ivory, 13½ x 10⅝ in. (34.2 x 26.8 cm).

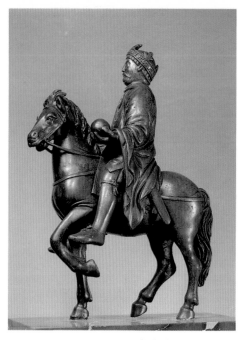

Equestrian Statuette of Charlemagne.
Carolingian, 9th century.
Bronze with traces of gilt, 9¼ in. (23.5 cm) high.

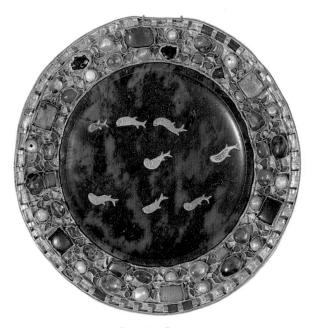

Serpentine Paten.
Alexandria(?), 1st century, and Saint Denis, 9th century.
Serpentine, gold, garnet, precious stones, 6⅝ in. (17 cm) diam.

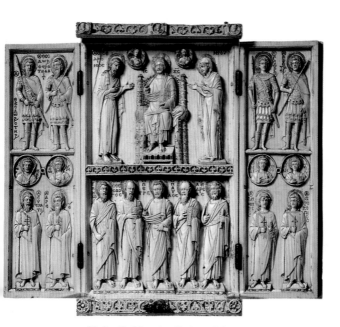

Harbaville Triptych: Christ and Saints.
Constantinople, mid-10th century. Ivory with traces of gilt
and polychrome, 9½ x 11¼ in. (24.2 x 28.5 cm).

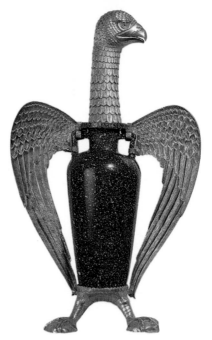

Eagle-Shaped Vase, called *Suger's Eagle.*
Saint Denis, before 1147. Ancient porphyry vase, gilt silver,
niello inlay, 17 x 10⅝ in. (43.1 x 27 cm).

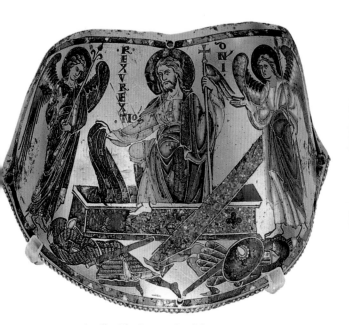

Armilla: The Resurrection. Meuse, c. 1170.
Gilt copper, champlevé enamel,
4⅜ x 5¾ in. (11.3 x 14.7 cm).

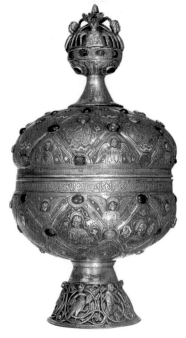

The Alpais Ciborium. Limoges, c. 1200.
Chased and engraved gilt copper, champlevé enamel, separate
mounts, gems, 11¾ in. (30 cm) high x 6⅝ in. (16.8 cm) diam.

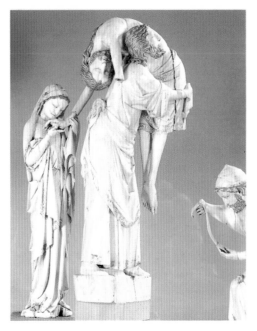

The Descent from the Cross. Paris, 3d quarter of 13th century.
Elephant ivory with traces of polychrome and gilt.
Height of group with Joseph and Christ: 11⅜ in. (29 cm);
height of the Virgin: 9⅝ in. (24.5 cm).

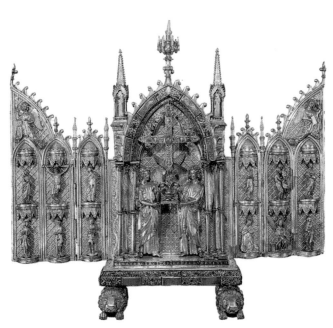

Reliquary Polyptych of the True Cross. Meuse or northern France, after 1254. Embossed, chased, and engraved gilt silver, niello inlay, gems, 31⅛ x 36¼ in. (79 x 92 cm).

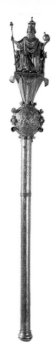

Charles V's Scepter. Paris, 1365–80.
Gold, formerly enameled (with fleur-de-lys), pearls, gems,
23⅝ in. (60 cm) high.

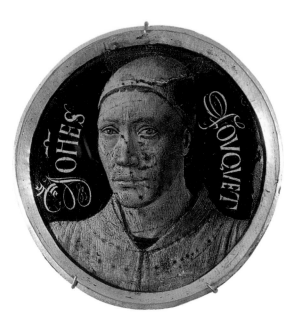

JEAN FOUQUET (c. 1420–1477/81). *Self-Portrait*, c. 1450.
Enameled copper; signed by the artist,
2⅝ in. (6.8 cm) diam.

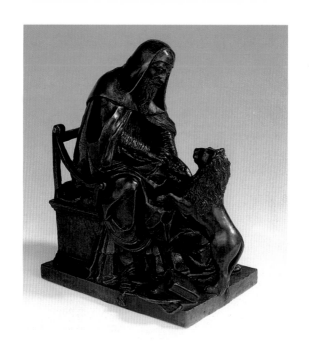

BARTOLOMEO BELLANO (c. 1440–1496/97).
Saint Jerome and the Lion, c. 1490–95. Bronze with crackleware
black patina, 9¾ x 8⅛ in. (25 x 20.5 cm).

ANDREA RICCIO (1470–1532).
Paradise, c. 1516–21.
Bronze with sepia patina, 14⅝ x 19⅜ in. (37 x 49 cm).

FONTANA WORKSHOP. *Childbirth Cup and Plate*, c. 1560–70.
Tin-glazed earthenware. Cup: 6½ in. (21.5 cm) diam.

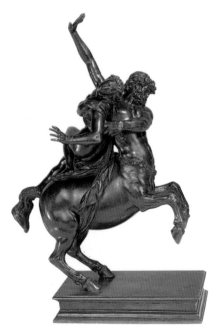

JEAN DE BOULOGNE (1529–1608). *Nessus and Deianira*, c. 1575–80.
Bronze with red-brown patina,
16⅝ x 12 in. (42.1 x 30.5 cm).

After BERNAERDT VAN ORLEY. *Month of August.* Brussels, c. 1528–33. Sixth tapestry from the series *Hunts of Maximilian.* Wool and silk with silver and gold thread, 14 ft. 8½ in. x 18 ft. 3 in. (4.48 x 5.58 m).

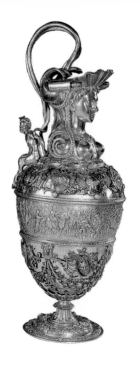

"Siege of Tunis" Ewer (opposite) and *Dish* (above).
Antwerp, 1558–59. Gilt and enameled silver.
Ewer: 17⅛ in. (43.5 cm) high; dish: 25¼ in. (64 cm) diam.

BERNARD PALISSY (1510?–1590).
Decorated Dish, c. 1560.
Glazed clay, 20⅝ x 15⅞ x 3 in. (52.5 x 40.3 x 7.4 cm).

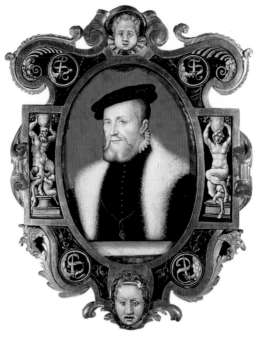

LÉONARD LIMOSIN (c. 1505–c. 1575). *Constable Anne de Montmorency*, 1556. Painted enamel on copper with gilt-wood setting, 28⅜ x 22 in. (72 x 56 cm).

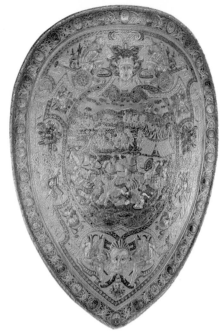

PIERRE REDON (d. c. 1572). *Charles IX's Shield*, c. 1572.
Embossed, enameled, and gold-plated iron,
26¾ x 18⅞ in. (68 x 49 cm).

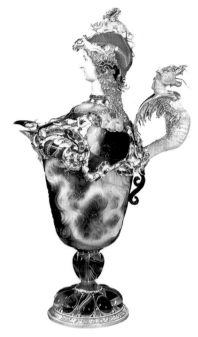

PIERRE DELABARRE (active 1625–after 1654). *Ewer.*
Stone, 1st century B.C. or A.D.; setting from Paris, c. 1630.
Sardonyx, enameled gold, 11 in. (28 cm) high.

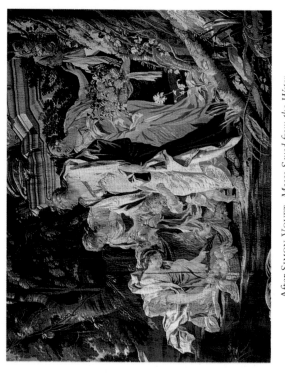

After SIMON VOUET. *Moses Saved from the Water*,
detail of the 3d tapestry from the *Old Testament* series. Louvre workshop,
c. 1630. Wool and silk, 16 ft. 2⅞ in. x 19 ft. 3½ in. (4.95 x 5.88 m).

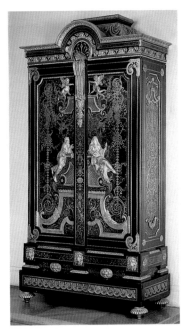

ANDRÉ-CHARLES BOULLE (1642–1732). *Armoire,* c. 1700–1710.
Oak and pine body, marquetry, ormolu mounts,
104⅜ x 53⅛ x 21¼ in. (265 x 135 x 54 cm).

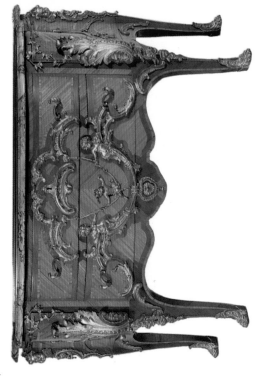

CHARLES CRESSENT (1685–1768). *Monkey Commode,* c. 1735–40.
Pine and oak body, satin and purple-wood veneer, ormolu mounts,
Sarrancolin marble, 35⅜ x 57⅞ x 24¾ in. (90 x 147 x 63 cm).

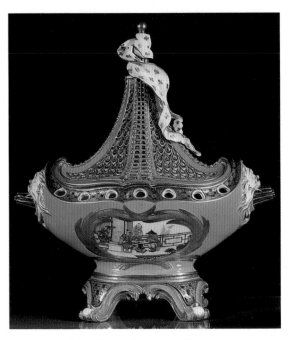

SÈVRES ROYAL PORCELAIN FACTORY.
Potpourri Vessel Belonging to Madame de Pompadour, 1760.
Soft-paste porcelain, 14⅝ x 13¾ in. (37 x 35 cm).

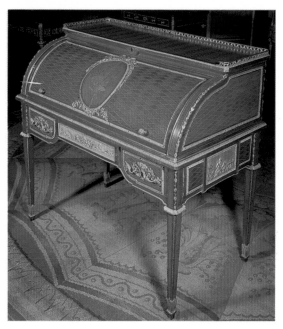

Jean-Henri Riesener (1734–1806).
Queen Marie-Antoinette's Rolltop Desk, 1784. Sycamore veneer
marquetry in lozenge pattern with ormolu mounts,
41⅜ x 44⅜ x 25⅛ in. (105 x 113 x 64 cm).

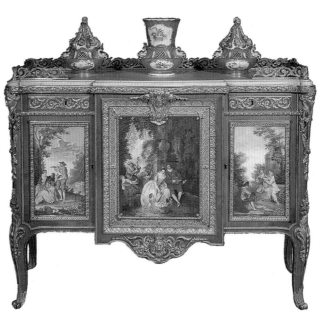

Martin Carlin (c. 1730-1785). *Commode with Three Doors for the Comtesse du Barry,* c. 1772. Wood marquetry and Sèvres porcelain panels, painted in 1765 after J.-B. Pater, N. Lancret, and C. Van Loo, 34⅜ x 47¼ x 18⅞ in. (87 x 120 x 48 cm).

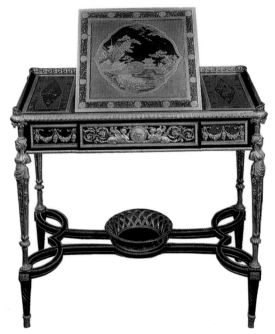

ADAM WEISWEILER (1744–1820).
Queen Marie-Antoinette's Writing Table, 1784. Oak body, ebony
marquetry, lacquer, mother-of-pearl, steel, ormolu mounts,
32⅜ x 18½ x 17⅜ in. (82 x 47 x 44 cm).

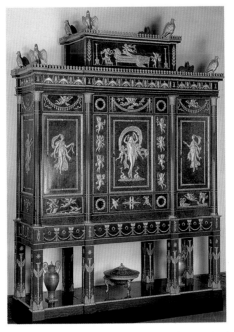

FRANÇOIS-HONORÉ JACOB-DESMALTER (1770–1841).
Empress Josephine's Jewel Cabinet, 1809.
Oak body, marquetry, mother-of-pearl, ormolu mounts,
108 x 79 x 24 in. (275 x 200 x 60 cm).

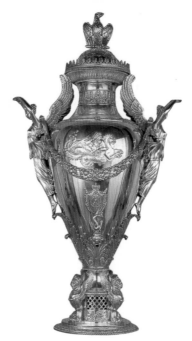

MARTIN-GUILLAUME BIENNAIS. *Part of Tea Service for Napoleon I,*
1809-10. Gilt silver; hot-water urn:
31½ x 17⅝ in. (80 x 45 cm).

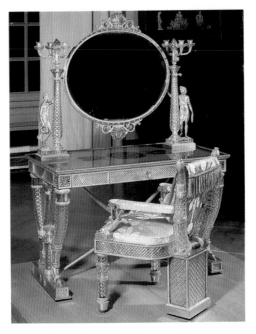

MARIE-JEANNE-ROSALIE DÉSARNAUD-CHARPENTIER,
after NICOLAS-HENRI JACOB (1782–1842). *Dressing Table,* c. 1819.
Crystal, gilt bronze, 66½ x 48 x 25⅛ in. (169 x 122 x 64 cm).

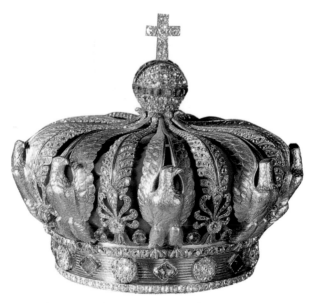

ALEXANDRE-GABRIEL LEMONNIER (c. 1808–1884).
Empress Eugénie's Crown, 1855.
Gold, 2,490 diamonds, 56 emeralds, 5⅛ x 5⅞ in. (13 x 15 cm).

Sculpture

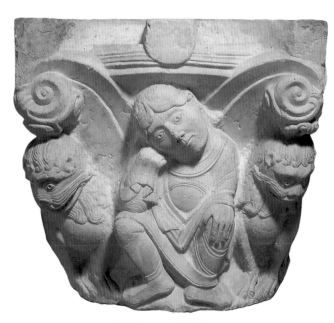

Daniel among the Lions.
Paris, 6th century and late 11th century.
Marble capital, 19⅝ x 20⅞ x 18⅞ in. (50 x 53 x 48 cm).

The Dead Christ, called *The Courajod Christ.* Burgundy,
2d quarter of 12th century. Wood with traces of gilt and
polychrome, 61 x 66⅛ x 11¾ in. (155 x 168 x 30 cm).

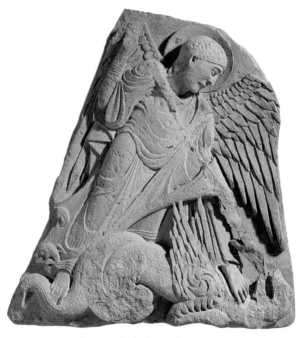

Saint Michael Slaying the Dragon.
2d quarter of 12th century.
Stone, 33½ x 30½ x 9¾ in. (85 x 77 x 25 cm).

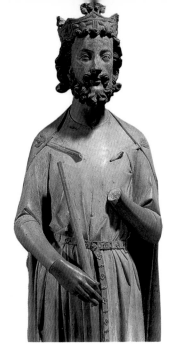

King Childebert. Ile-de-France, c. 1239–44.
Stone with traces of polychrome,
75¼ x 20⅞ x 22 in. (191 x 53 x 55 cm).

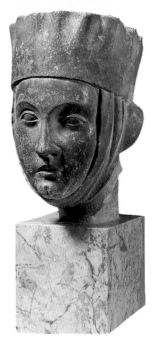

Head of a Woman with Hat in the Shape of a Tower,
2d quarter of 13th century.
Stone, 8⅜ x 6½ x 7⅞ in. (21 x 16 x 20 cm).

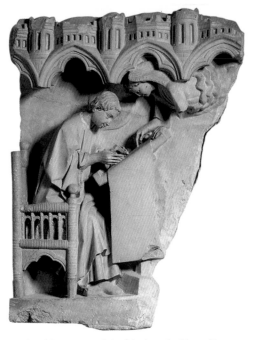

Angel Dictating to Saint Matthew the Evangelist.
Chartres, 2d quarter of 13th century.
Stone, 26 x 19⅝ in. (66 x 50 cm).

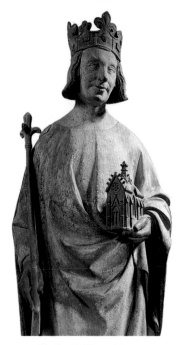

Charles V, King of France.
Ile-de-France, late 14th century.
Stone, 76¾ x 28 x 16⅛ in. (195 x 71 x 41 cm).

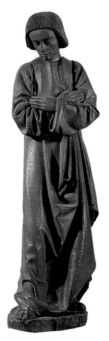

Saint John on Calvary. Loire Valley, 3d quarter of 15th century.
Wood with traces of polychrome,
55⅛ x 18⅛ x 15½ in. (140 x 46 x 39 cm).

Tomb of Philippe Pot.
Burgundy, late 15th century.
Painted stone, 70⅞ x 104 ½ in. (180 x 265 cm).

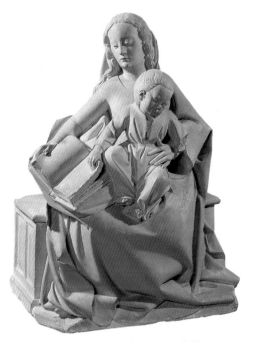

The Education of the Holy Child.
Bourbonnais, late 15th century.
Stone with traces of polychrome, 31⅛ x 17⅝ in. (79 x 45 cm).

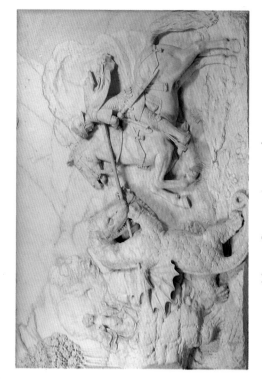

MICHEL COLOMBE (c. 1430–after 1511?).
Saint George Fighting the Dragon, 1508–9.
Marble, 68⅞ x 107⅛ in. (175 x 272 cm).

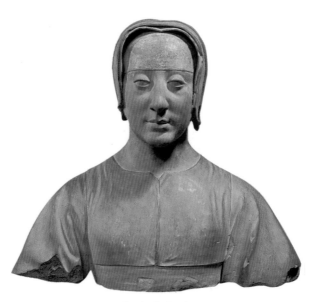

Louise de Savoie.
Loire Valley, early 16th century.
Terra-cotta, 18½ x 21¼ x 9⅛ in. (47 x 54 x 23 cm).

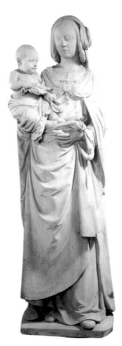

WORKSHOP OF GUILLAUME REGNAULT (c. 1460–1532).
Virgin and Child, early 16th century.
Marble, 72 x 23⅝ in. (183 x 60 cm).

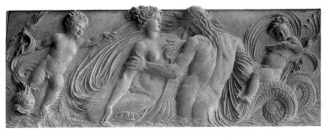

JEAN GOUJON (c. 1510-c. 1565).
Nymph and Putto, c. 1547-49.
Stone, 28⅝ x 76¾ x 5⅛ in. (73 x 195 x 13 cm).

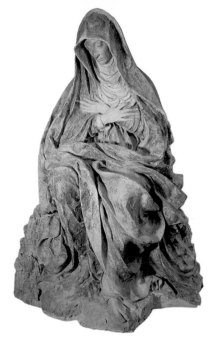

GERMAIN PILON (c. 1528–1590).
Virgin of the Sorrows, c. 1585. Polychrome terra-cotta,
66⅛ x 46⅞ x 30⅝ in. (168 x 119 x 78 cm).

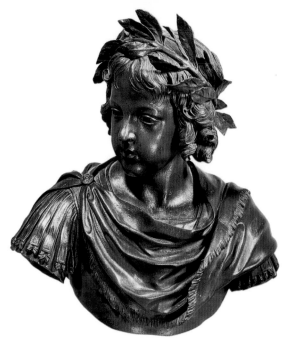

JACQUES SARRAZIN (1592–1660).
Louis XIV as a Child, 1643.
Bronze, 18½ x 17⅜ x 9⅜ in. (47 x 44 x 24 cm).

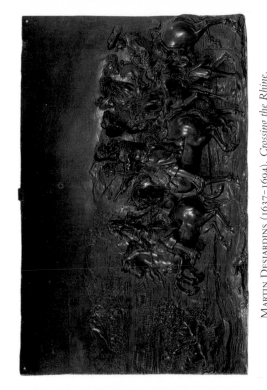

MARTIN DESJARDINS (1637–1694). *Crossing the Rhine.*
From the place des Victoires, Paris.
Bronze, 43 3/8 x 66 1/8 x 4 5/8 in. (110 x 168 x 12 cm).

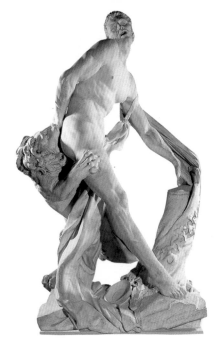

PIERRE PUGET (1620–1694).
Milo of Crotona Devoured by a Lion, 1670–83.
Marble, 106¼ x 55⅛ x 38⅝ in. (270 x 140 x 98 cm).

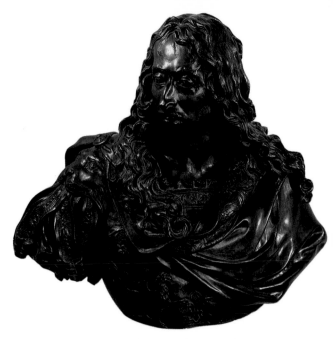

ANTOINE COYSEVOX (1640–1720).
The Prince of Condé, 1688.
Bronze, 29½ x 27⅝ x 12⅝ in. (75 x 70 x 32 cm).

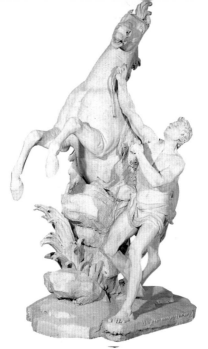

GUILLAUME COUSTOU (1677–1746).
Horse Restrained by a Groom, called *The Marly Horse*, 1739-45.
Marble, 129¾ x 111¾ x 45⅜ in. (355 x 284 x 115 cm).

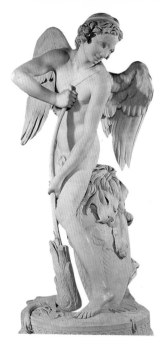

EDMÉ BOUCHARDON (1698-1762).
Cupid Cutting His Bow from Hercules' Club, 1739-50.
Marble, 68⅛ x 29½ x 29½ in. (173 x 75 x 75 cm).

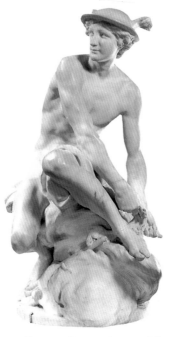

JEAN-BAPTISTE PIGALLE (1714–1785).
Mercury Attaching His Wings, 1744.
Marble, 23¼ x 13¾ x 11¾ in. (59 x 35 x 30 cm).

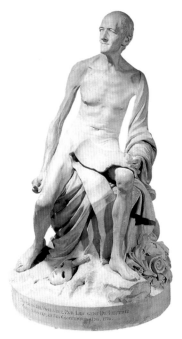

Jean-Baptiste Pigalle (1714–1785).
Voltaire, 1776.
Marble, 59 x 35 x 30 ⅜ in. (150 x 89 x 77 cm).

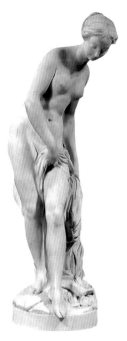

ÉTIENNE-MAURICE FALCONET (1716–1791).
Bather, 1757.
Marble, 32⅜ x 10¼ x 11 in. (82 x 26 x 28 cm).

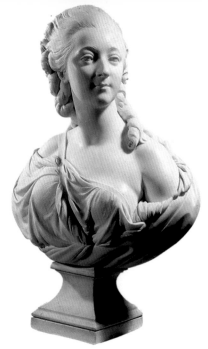

AUGUSTIN PAJOU (1730–1809).
The Comtesse du Barry, 1773.
Marble, 28½ x 19⅛ x 10¼ in. (72 x 48.5 x 26 cm).

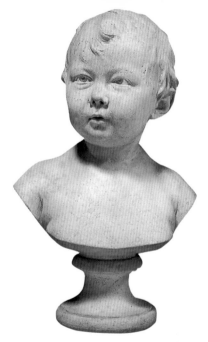

Jean-Antoine Houdon (1741–1828).
Sabine Houdon at Six Months, 1788.
Plaster, 15 x 9⅝ x 6⅝ in. (38 x 24.7 x 16.8 cm).

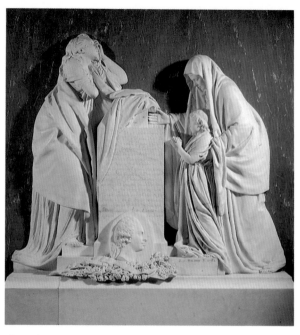

JEAN-ANTOINE HOUDON (1741–1828). *Mausoleum for the Heart of Victor Charpentier, the Comte d'Énnery,* 1781. Marble, 91½ x 88⅝ in. (232 x 225 cm).

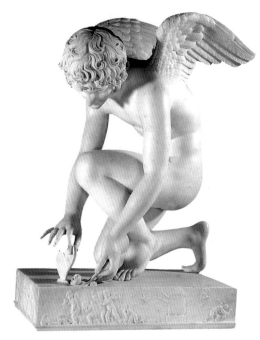

ANTOINE-DENIS CHAUDET (1763–1810).
Cupid, 1802. Realized by Cartelier, 1817.
Marble, 31½ x 17½ x 25¼ in. (80 x 44 x 64 cm).

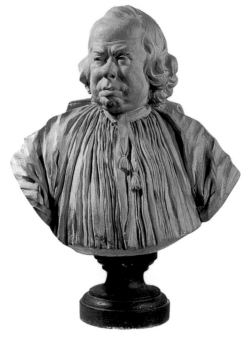

JEAN-JACQUES CAFFIERI (1725–1792).
Canon Alexandre-Gui Pingré, 1788.
Terra-cotta, 26⅝ x 20½ x 13⅝ in. (67.5 x 51.5 x 34.6 cm).

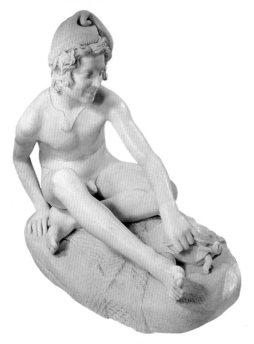

FRANÇOIS RUDE (1784–1855).
Young Neapolitan Fisherboy Playing with a Tortoise, 1831–33.
Marble, 32½ x 34⅝ x 18⅞ in. (82 x 88 x 48 cm).

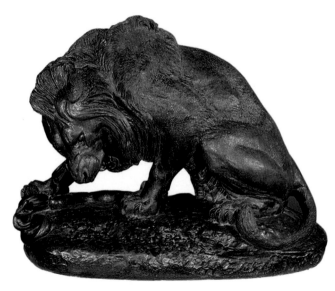

ANTOINE-LOUIS BARYE (1796–1875).
Lion Fighting a Serpent, 1832.
Bronze, 53⅛ x 70⅛ x 37¾ in. (135 x 178 x 96 cm).

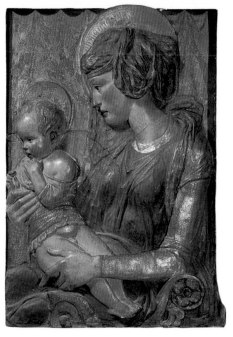

DONATELLO (1386–1466).
Virgin and Child, 1440. Polychrome terra-cotta,
40¼ x 29½ x 4⅝ in. (102 x 75 x 12 cm).

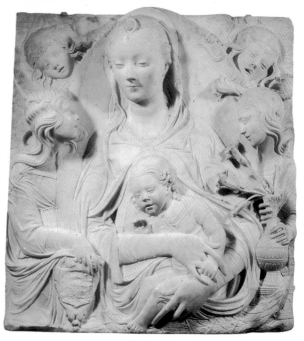

AGOSTINO D'ANTONIO DI DUCCIO (1418-1481).
Virgin and Child Surrounded by Angels. Florence, 3d quarter
of 15th century. Marble, 31⅞ x 30 ½ in. (81 x 77 cm).

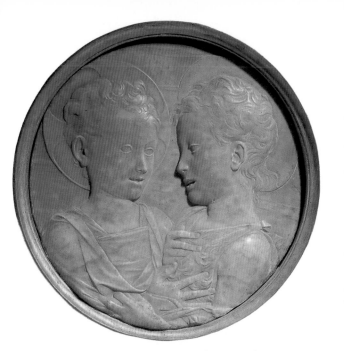

DESIDERIO DA SETTIGNANO (1428–1464).
Christ and Saint John the Baptist as Children.
Marble, 20⅛ in. (51 cm) diam.

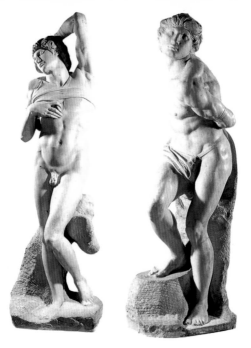

MICHELANGELO BUONARROTI (1475–1564).
Slaves, 1513–15 (unfinished).
Marble, 82⅜ in. (209 cm) high.

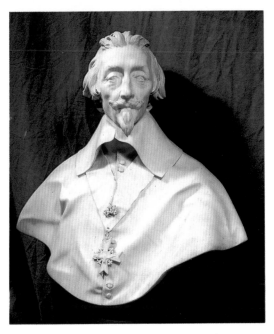

GIAN LORENZO BERNINI (1598–1680).
Cardinal Armand de Richelieu, 1640–41.
Marble, 33⅛ x 27⅝ x 13 in. (84 x 70 x 32 cm).

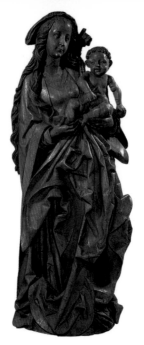

Virgin and Child.
Upper Rhine, late 15th century.
Limewood, 67⅝ x 29⅞ x 19½ in. (172 x 76 x 49.5 cm).

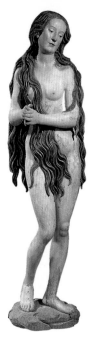

GREGOR ERHART (died 1540).
Saint Mary Magdalene, early 16th century. Polychrome
limewood, 69⅝ x 17⅜ x 16⅞ in. (177 x 44 x 43 cm).

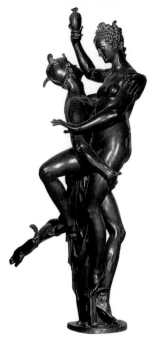

ADRIAAN DE VRIES (1546–1626).
Mercury and Psyche, 1593.
Bronze, 84⅝ x 36¼ x 28⅜ in. (215 x 92 x 72 cm).

EUROPEAN
PAINTINGS

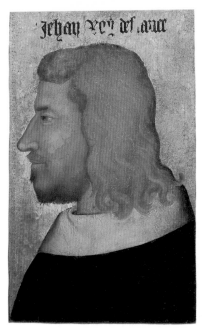

Jean II, called *Jean the Good, King of France*, c. 1350.
Wood, 23⅝ x 17½ in. (60 x 44.5 cm).

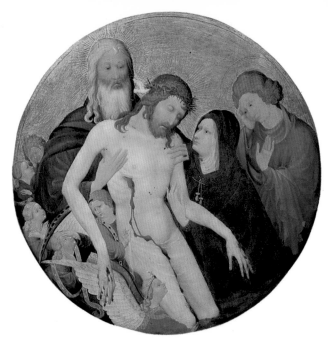

JEAN MALOUEL (before 1370–1415).
Pietà, c. 1400.
Wood, 25⅜ in. (64.5 cm) diam.

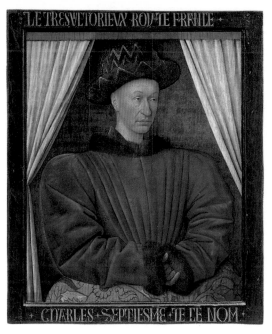

Jean Fouquet (c. 1420–1477/81).
Charles VII, King of France, c. 1445–50.
Wood, 33⅞ x 28 in. (86 x 71 cm).

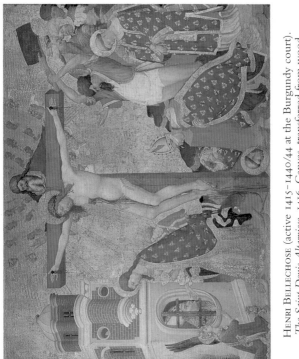

HENRI BELLECHOSE (active 1415–1440/44 at the Burgundy court). *The Saint Denis Altarpiece*, 1416. Canvas, transferred from wood, 63¾ in. x 83⅛ in. (162 x 211 cm).

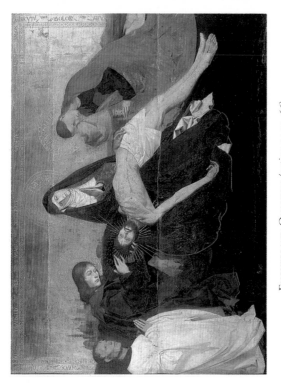

ENGUERRAND QUARTON (active 1444–66).
The Villeneuve-lès-Avignon Pietà, c. 1455.
Wood, 64¼ x 86 in. (163 x 218.5 cm).

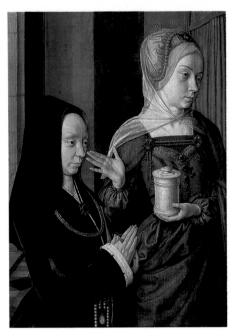

JEAN HEY, called the Master of Moulins (active 1480–1500). *Madeleine de Bourgogne(?), Presented by Saint Mary Magdalene,* c. 1490. Wood, 22 x 15⅝ in. (56 x 40 cm).

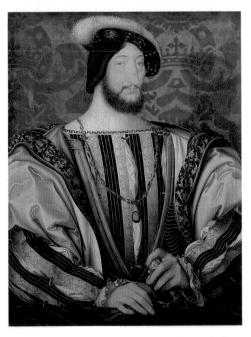

Attributed to JEAN CLOUET (1485/90?–1540/41?).
François I, King of France, c. 1530(?).
Wood, 37¾ x 29⅛ in. (96 x 74 cm).

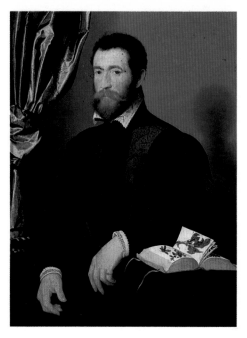

FRANÇOIS CLOUET (d. 1572).
Pierre Quthe, Apothecary, 1562.
Wood, 35¾ x 27½ in. (91 x 70 cm).

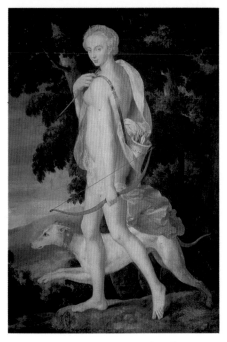

SCHOOL OF FONTAINEBLEAU, mid-16th century.
Diana the Huntress, c. 1550.
Canvas, 75 x 52 in. (191 x 132 cm).

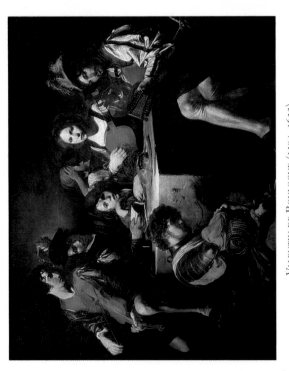

VALENTIN DE BOULOGNE (1594–1632).
Concert with Roman Bas-Relief, c. 1622–25.
Canvas, 68⅛ x 84⅜ in. (173 x 214 cm).

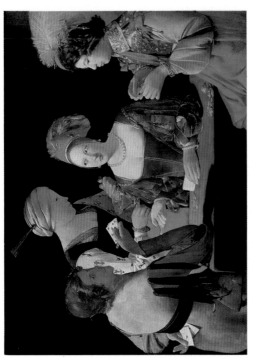

GEORGES DE LA TOUR (1593–1652).
The Cheat, c. 1635–40.
Canvas, 41⅝ x 57½ in. (106 x 146 cm).

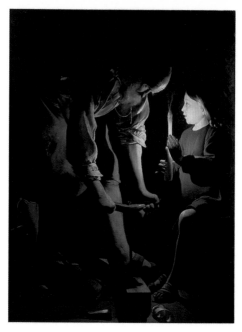

GEORGES DE LA TOUR (1593–1652).
Christ with Saint Joseph in the Carpenter's Shop, c. 1640.
Canvas, 53⅞ x 40¼ in. (137 x 102 cm).

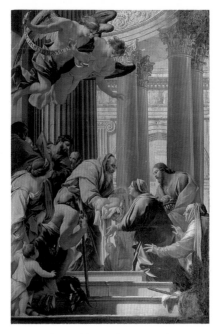

SIMON VOUET (1590–1649).
The Presentation in the Temple, 1641.
Canvas, 12 ft. 10⅝ in. x 8 ft. 2¼ in. (3.93 x 2.5 m).

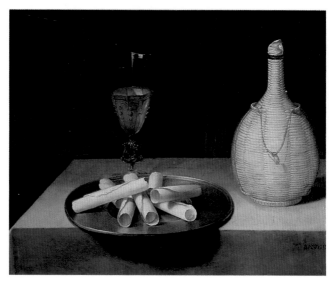

LUBIN BAUGIN (c. 1612–1663).
Still Life with Wafer Biscuits, c. 1630–35.
Wood, 16⅛ x 54½ in. (41 x 52 cm).

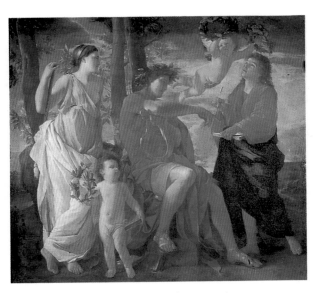

NICOLAS POUSSIN (1594–1665).
The Poet's Inspiration, c. 1630(?).
Canvas, 71⅞ x 83⅞ in. (182.5 x 213 cm).

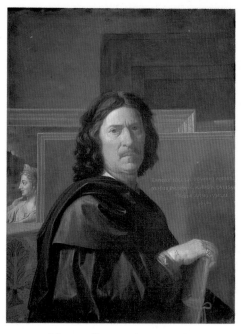

NICOLAS POUSSIN (1594–1665).
Self-Portrait, 1650.
Canvas, 38⅝ x 29⅛ in. (98 x 74 cm).

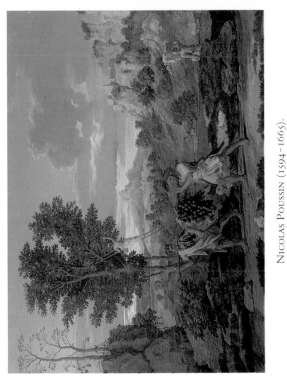

NICOLAS POUSSIN (1594–1665).
Autumn, c. 1660–64.
Canvas, 46½ x 63 in. (118 x 160 cm).

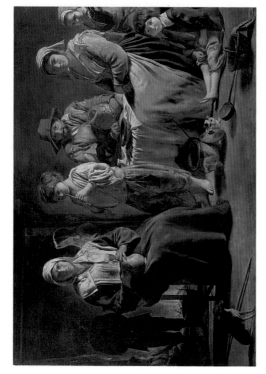

LOUIS (or ANTOINE?) LE NAIN (c. 1600/1610–1648).
The Peasant Family, c. 1640–45.
Canvas, 44½ x 62⅝ in. (113 x 159 cm).

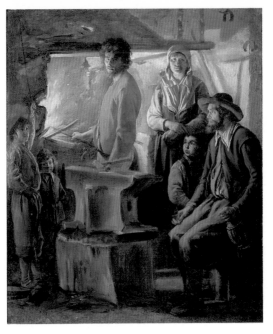

Louis (or Antoine?) Le Nain (c. 1600/1610–1648).
The Forge, c. 1640–45.
Canvas, 27⅛ x 22⅜ in. (69 x 57 cm).

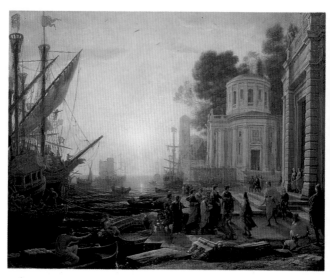

CLAUDE LORRAIN (c. 1602–1682).
The Disembarkation of Cleopatra at Tarsus, 1642.
Canvas, 46⅞ x 66⅛ in. (119 x 168 cm).

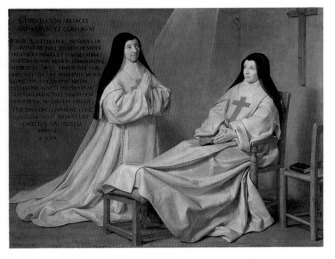

PHILIPPE DE CHAMPAIGNE (1602–1674).
The Ex-Voto of 1662, 1662.
Canvas, 65 x 90¼ in. (165 x 229 cm).

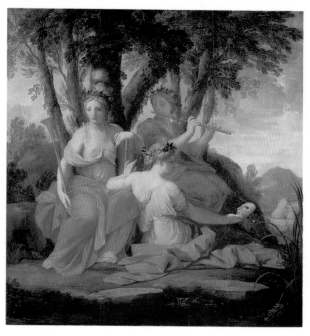

EUSTACHE LE SUEUR (1616–1655).
Clio, Euterpe, and Thalia, c. 1652.
Wood, 51¼ x 51¼ in. (130 x 130 cm).

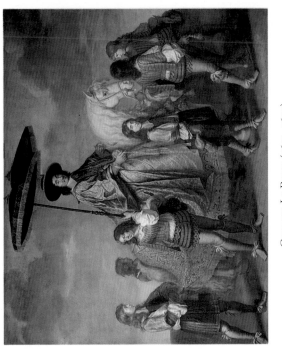

CHARLES LE BRUN (1619–1690).
Chancellor Séguier, c. 1655–57.
Canvas, 9 ft. 8½ in. x 11 ft. 6¼ in. (2.95 x 3.51 m).

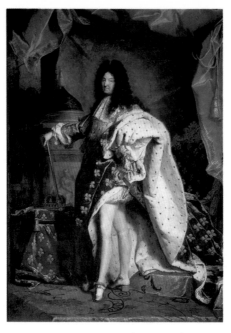

HYACINTHE RIGAUD (1659–1743).
Louis XIV, King of France, 1701.
Canvas, 109 x 76⅜ in. (277 x 194 cm).

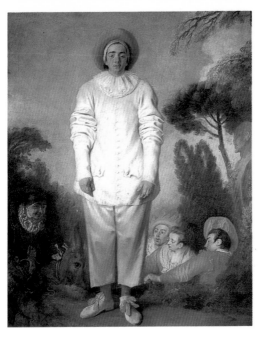

JEAN-ANTOINE WATTEAU (1684-1721).
Pierrot, also called *Gilles,* c. 1718-19.
Canvas, 72⅜ x 58⅝ in. (184 x 149 cm).

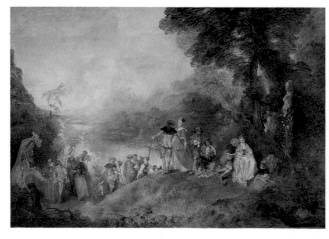

Jean-Antoine Watteau (1684–1721).
The Pilgrimage to Cythera, 1717.
Canvas, 50¾ x 76⅜ in. (129 x 194 cm).

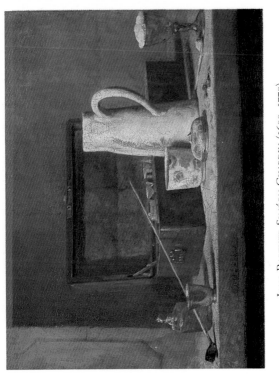

JEAN-BAPTISTE-SIMÉON CHARDIN (1699–1779).
Pipes and Drinking Pitcher, c. 1737.
Canvas, 12¾ x 16½ in. (32.5 x 42 cm).

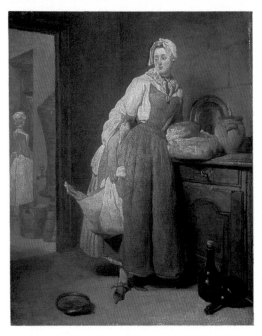

JEAN-BAPTISTE-SIMÉON CHARDIN (1699–1779).
The Return from Market, 1739.
Canvas, 18½ x 15 in. (47 x 38 cm).

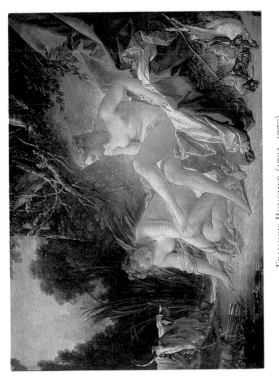

FRANÇOIS BOUCHER (1703–1770).
Diana Leaving Her Bath, 1742.
Canvas, 22 x 28⅝ in. (56 x 73 cm).

JEAN-HONORÉ FRAGONARD (1732–1806).
The Bathers, c. 1765.
Canvas, 25¼ x 31½ in. (64 x 80 cm).

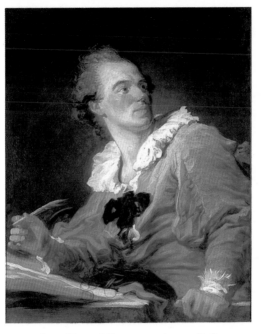

JEAN-HONORÉ FRAGONARD (1732–1806).
Inspiration, c. 1769.
Canvas, 31½ x 25¼ in. (80 x 64 cm).

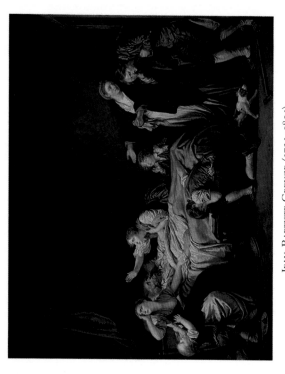

JEAN-BAPTISTE GREUZE (1725–1805).
The Wicked Son Punished, 1778.
Canvas, 51¼ x 64¼ in. (130 x 163 cm).

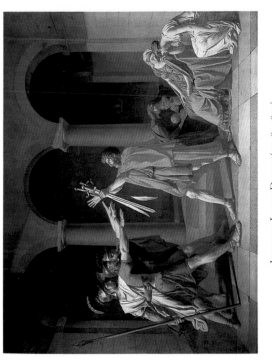

JACQUES-LOUIS DAVID (1748–1825).
The Oath of the Horatii, 1784.
Canvas, 10 ft. 9⅞ in. x 13 ft. 11¼ in. (3.3 x 4.25 m).

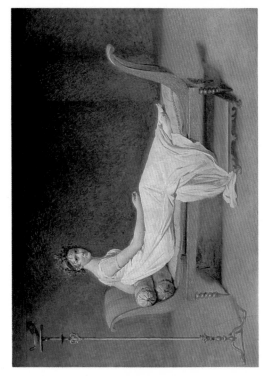

Jacques-Louis David (1748–1825).
Madame Récamier, 1800.
Canvas, 68½ x 96 in. (174 x 244 cm).

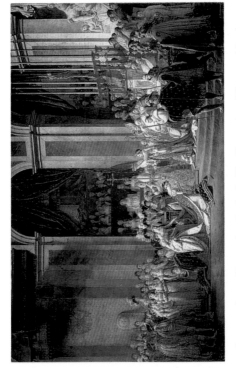

JACQUES-LOUIS DAVID (1748–1825). *The Coronation of Emperor Napoleon and Empress Josephine, December 2, 1804*, 1806–7. Canvas, 20 ft. 4½ in. x 32 ft. 1¼ in. (6.21 x 9.79 m).

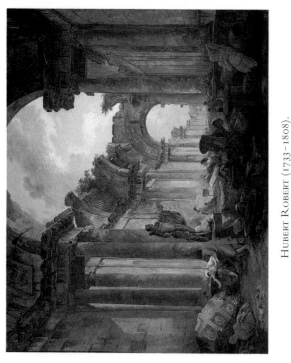

HUBERT ROBERT (1733–1808).
Imaginary View of the Louvre's Grande Galerie in Ruins, Salon of 1796.
Canvas, 45 x 57½ in. (114.5 x 146 cm).

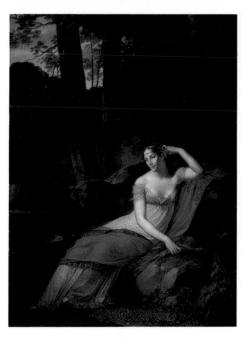

PIERRE-PAUL PRUD'HON (1758–1823).
The Empress Josephine, 1805.
Canvas, 96⅛ x 70½ in. (244 x 179 cm).

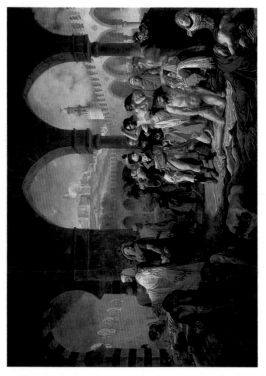

ANTOINE-JEAN GROS (1771–1835). *Napoleon Bonaparte Visiting the Plague Victims at Jaffa* (*March 11, 1799*), 1804. Canvas, 17 ft. 1⅞ in. x 23 ft. 5⅛ in. (5.23 x 7.15 m).

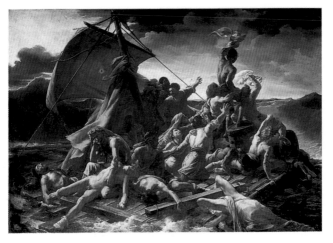

THÉODORE GÉRICAULT (1781–1824).
The Raft of the Medusa, 1819.
Canvas, 16 ft. 1⅜ in. x 23 ft. 5⅞ in. (4.91 x 7.16 m).

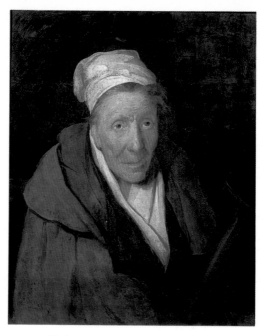

THÉODORE GÉRICAULT (1781–1824).
The Madwoman, c. 1822.
Canvas, 30⅜ x 25⅜ in. (77 x 64.5 cm).

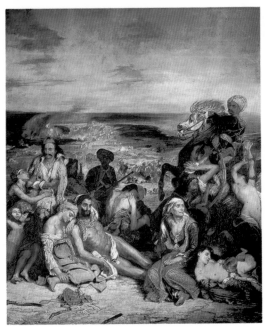

EUGÈNE DELACROIX (1798–1863).
The Massacre at Chios, 1824.
Canvas, 13 ft. 9 in. x 11 ft. 7⅜ in. (4.19 x 3.54 m).

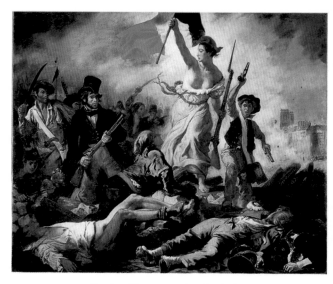

Eugène Delacroix (1798–1863).
Liberty Leading the People (July 28, 1830), 1830.
Canvas, 8 ft. 6⅜ in. x 10 ft. 8 in. (2.6 x 3.25 m).

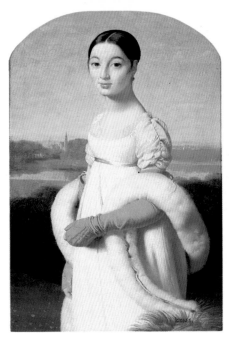

Jean-Auguste-Dominique Ingres (1780-1867).
Mademoiselle Rivière, Salon of 1806.
Canvas, 39⅜ x 27⅝ in. (100 x 70 cm).

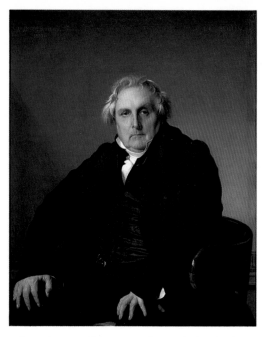

Jean-Auguste-Dominique Ingres (1780–1867).
Louis-François Bertin, 1832.
Canvas, 45⅝ x 37⅜ in. (116 x 95 cm).

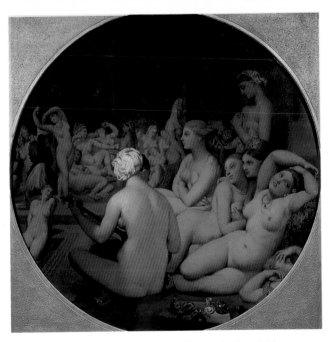

JEAN-AUGUSTE-DOMINIQUE INGRES (1780–1867).
The Turkish Bath, 1862.
Canvas on wood, 43⅜ x 43⅜ in. (110 x 110 cm).

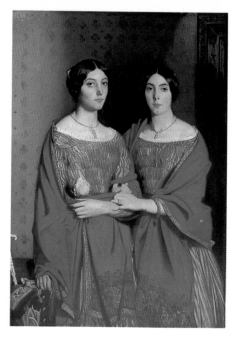

THÉODORE CHASSÉRIAU (1819–1856).
The Two Sisters, 1843.
Canvas, 70⅛ x 53⅛ in. (180 x 135 cm).

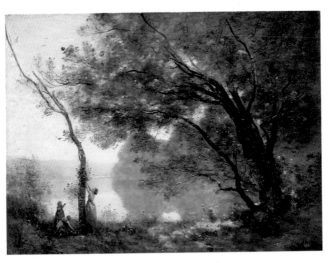

Jean-Baptiste-Camille Corot (1796–1875).
Souvenir de Mortefontaine, Salon of 1864.
Canvas, 25⅝ x 35 in. (65 x 89 cm).

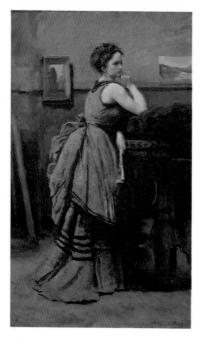

JEAN-BAPTISTE-CAMILLE COROT (1796–1875).
Woman in Blue, 1874.
Canvas, 31½ x 19⅞ in. (80 x 50.5 cm).

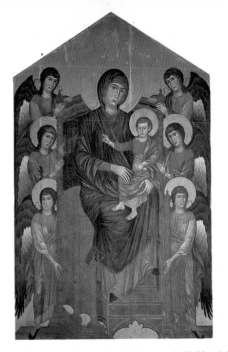

CIMABUE (c. 1240–after 1302). *Madonna and Child in Majesty
Surrounded by Angels*, c. 1270(?).
Wood, 14 ft. x 9 ft. 2¾ in. (4.27 x 2.8 m).

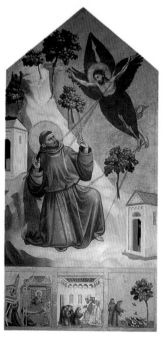

GIOTTO (c. 1267–1337).
Saint Francis of Assisi Receiving the Stigmata, c. 1290–95.
Wood, 123¾ x 64¾ in. (313 x 163 cm).

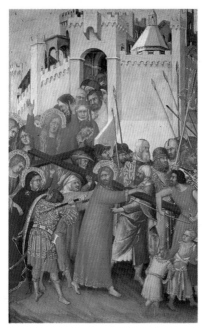

SIMONE MARTINI (c. 1284–1344).
The Carrying of the Cross, c. 1325–35.
Wood, 11 x 6⅜ in. (28 x 16 cm).

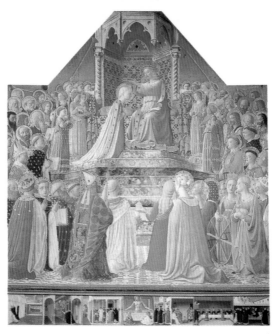

Fra Angelico (before 1417–1455).
The Coronation of the Virgin, before 1435.
Wood, 82⅜ x 81⅛ in. (209 x 206 cm).

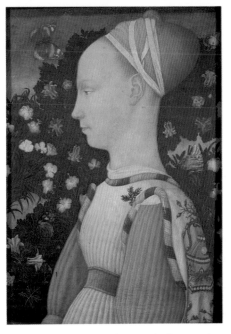

Antonio Pisanello (1395 or before–1455).
A Princess of the Este Family, c. 1436–38(?).
Wood, 16⅞ x 11⅜ in. (43 x 30 cm).

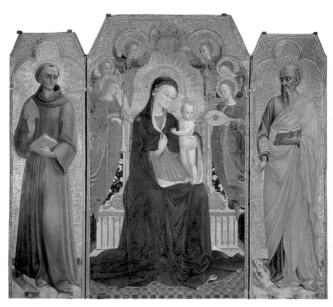

STEFANO DI GIOVANNI SASSETTA (1392?–1450). *The Madonna and Child Surrounded by Six Angels, Saint Anthony of Padua, Saint John the Evangelist*, c. 1437–44. Wood, three panels, 76⅞ x 91¼ in. (195 x 232 cm), overall.

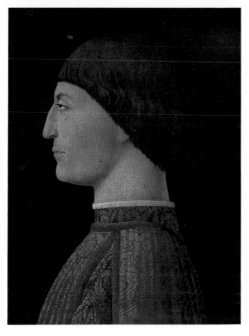

PIERO DELLA FRANCESCA (c. 1422–1492).
Sigismondo Malatesta, c. 1450.
Wood, 17⅜ x 13⅜ in. (44 x 34 cm).

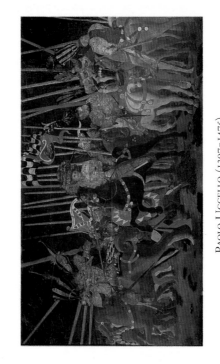

PAOLO UCCELLO (1397–1475).
The Battle of San Romano, c. 1455.
Wood, 72 x 120½ in. (182 x 317 cm).

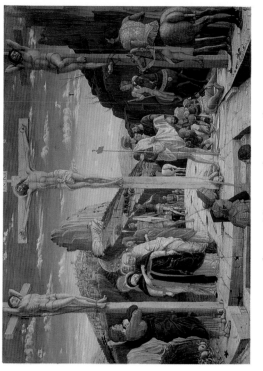

ANDREA MANTEGNA (1431–1506).
Calvary, c. 1456–59.
Wood, 29⅞ x 37¾ in. (76 x 96 cm).

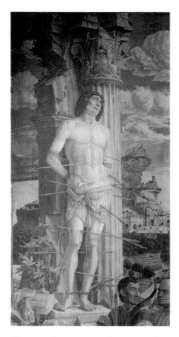

ANDREA MANTEGNA (1431–1506).
Saint Sebastian, c. 1480.
Canvas, 100⅜ x 55⅛ in. (255 x 140 cm).

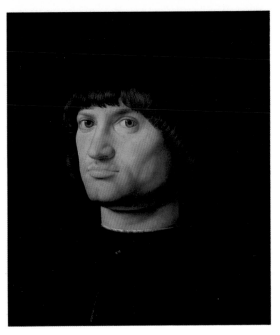

ANTONELLO DA MESSINA (active 1456–1479).
Portrait of a Man, called *Il Condottiere*, 1475.
Wood, 14¼ x 11¾ in. (36 x 30 cm).

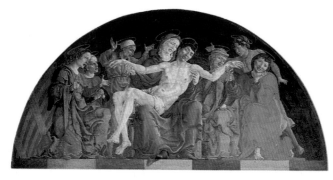

COSIMO TURA (c. 1430–1495).
Pietà, c. 1480.
Wood, 52 x 101½ in. (132 x 268 cm).

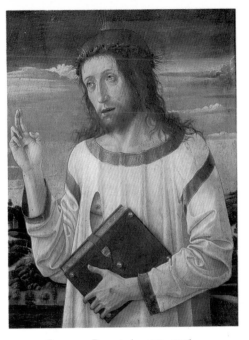

GIOVANNI BELLINI (c. 1430–1516).
Christ's Blessing, c. 1460.
Wood, 22¾ x 18⅛ in. (58 x 46 cm).

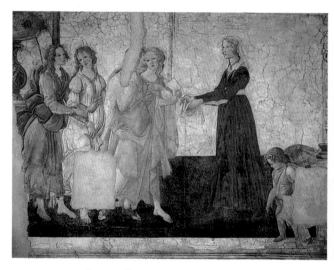

SANDRO BOTTICELLI (c. 1445–1510).
Venus and the Graces Offering Gifts to a Young Girl, c. 1483.
Fresco, 83⅛ x 111⅜ in. (211 x 283 cm).

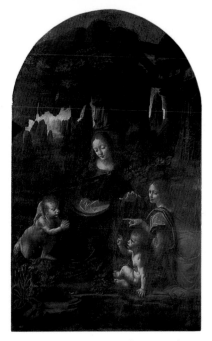

LEONARDO DA VINCI (1452–1519).
The Virgin of the Rocks, 1483–86.
Canvas, transferred from wood, 78⅜ x 48 in. (199 x 122 cm).

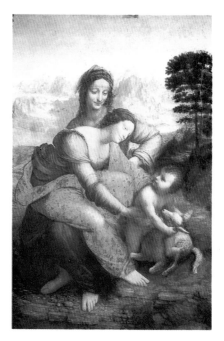

LEONARDO DA VINCI (1452–1519).
The Virgin and Child with Saint Anne, 1508–10.
Wood, 66⅛ x 51¼ in. (168 x 130 cm).

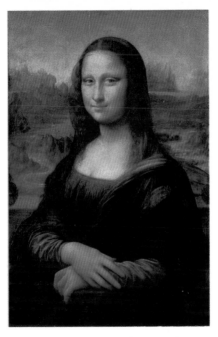

LEONARDO DA VINCI (1452–1519).
Mona Lisa, also called *La Gioconda*, 1503–6.
Wood, 30¼ x 21 in. (76.8 x 53.3 cm).

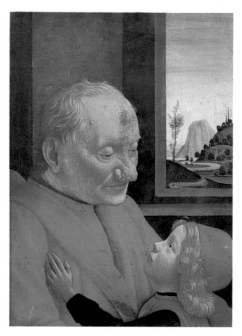

DOMENICO GHIRLANDAIO (1449–1494).
Old Man with a Young Boy, c. 1490.
Wood, 24⅝ x 18¼ in. (62.7 x 46.3 cm).

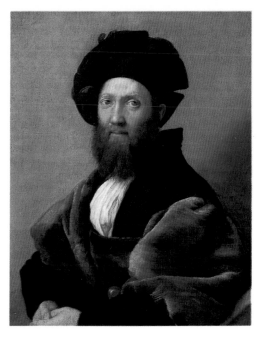

RAPHAEL (1483–1520).
Baldassare Castiglione, c. 1514–15.
Canvas, 32⅜ x 26⅜ in. (82 x 67 cm).

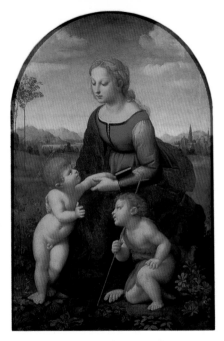

RAPHAEL (1483–1520).
The Virgin and Child with Saint John the Baptist, 1507.
Wood, 48 x 31½ in. (122 x 80 cm).

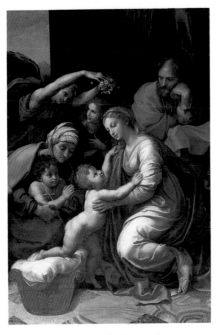

RAPHAEL (1483–1520).
The Holy Family, 1518.
Canvas, 74⅜ x 55⅛ in. (190 x 140 cm).

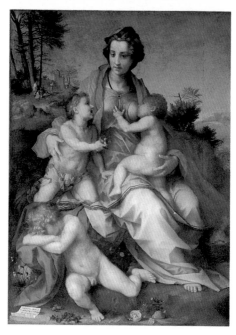

ANDREA DEL SARTO (1486–1530).
Charity, 1518.
Canvas, 72⅜ x 53⅞ in. (185 x 137 cm).

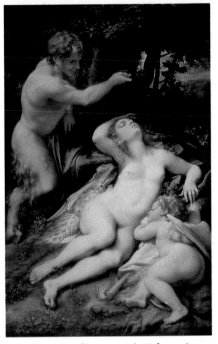

ANTONIO CORREGGIO (1489?–1534).
Venus, Satyr, and Cupid, c. 1525.
Canvas, 74⅜ x 48⅜ in. (190 x 124 cm).

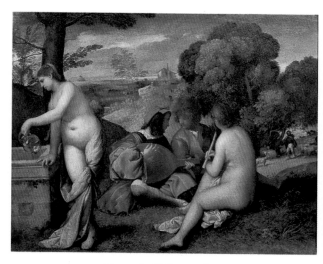

TITIAN (1488/89-1576).
Le Concert champêtre, c. 1510-11.
Canvas, 43⅜ x 54⅜ in. (110 x 138 cm).

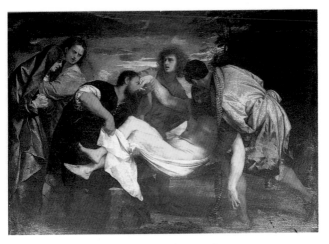

TITIAN (1488/89–1576).
The Entombment, c. 1525.
Canvas, 50 x 64¾ in. (127 x 163 cm).

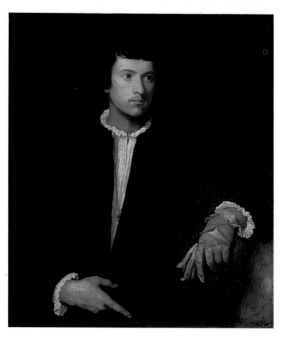

TITIAN (1488/89-1576).
Portrait of a Man, called *Man with a Glove*, c. 1520-25.
Canvas, 39⅜ x 35 in. (100 x 89 cm).

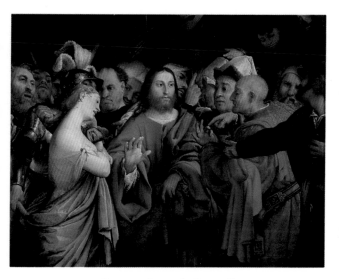

LORENZO LOTTO (1480–1556).
Christ and the Adulteress, c. 1530–35.
Canvas, 48⅜ x 61⅜ in. (124 x 156 cm).

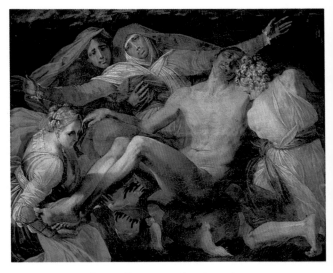

Rosso Fiorentino (1496–1540).
Pietà, c. 1530–35.
Canvas, transferred from wood, 50 x 64¾ in. (127 x 163 cm).

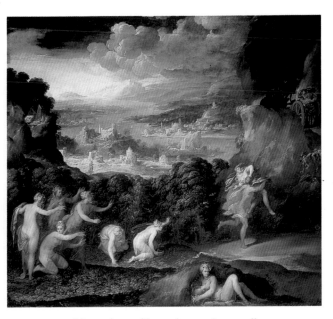

NICCOLÒ DELL'ABATE (c. 1509/12–1571?).
The Rape of Proserpina, c. 1560.
Canvas, 77¾ x 85⅜ in. (196 x 218 cm).

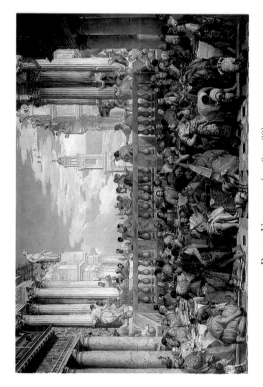

PAOLO VERONESE (1528–1588).
The Wedding Feast at Cana, 1562–63.
Canvas, 21 ft. 10¾ in. x 32 ft. 5¾ in. (6.66 x 9.9 m).

274

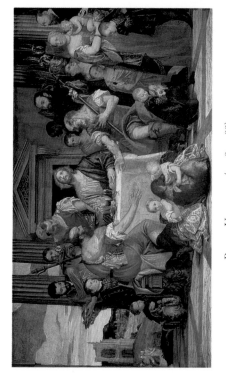

PAOLO VERONESE (1528–1588).
The Supper at Emmaus, c. 1559–60.
Canvas, 9 ft. 6¼ in. x 14 ft. 8⅜ in. (2.9 x 4.48 m).

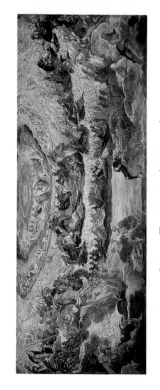

JACOPO TINTORETTO (1518–1594).
Paradise, c. 1578–79.
Canvas, 56⅜ x 142½ in. (143 x 362 cm).

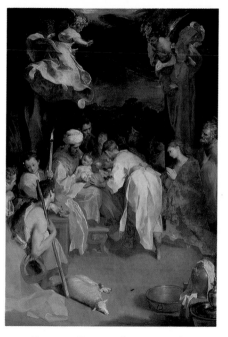

Federico Barocci (c. 1535–1612).
The Circumcision, 1590.
Canvas, 130¼ x 98¾ in. (356 x 251 cm).

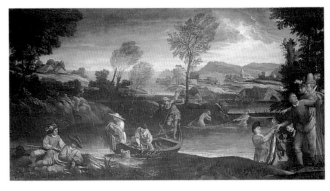

ANNIBALE CARRACCI (1560-1641).
Fishing, c. 1585-88.
Canvas, 53⅛ x 99⅝ in. (135 x 253 cm).

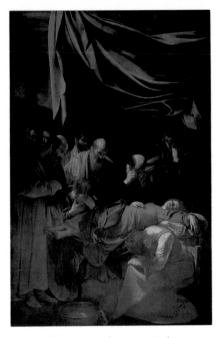

CARAVAGGIO (c. 1571–1610).
The Death of the Virgin, 1605–6.
Canvas, 12 ft. 1⅜ in. x 8 ft. (3.69 x 2.45 m).

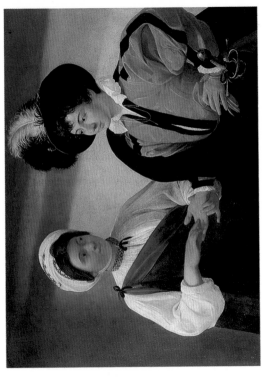

CARAVAGGIO (c. 1571–1610).
The Fortune Teller, c. 1594–95.
Canvas, 39 x 51⅝ in. (99 x 131 cm).

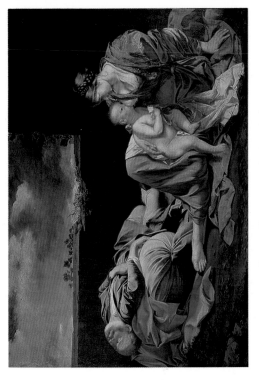

ORAZIO GENTILESCHI (1563–1639).
Rest on the Flight into Egypt, c. 1628.
Canvas, 62¼ x 88⅝ in. (158 x 225 cm).

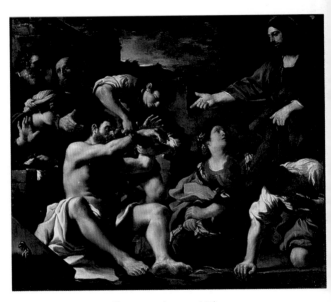

GUERCINO (1591–1666).
The Raising of Lazarus, c. 1619.
Canvas, 78⅜ x 91⅝ in. (199 x 233 cm).

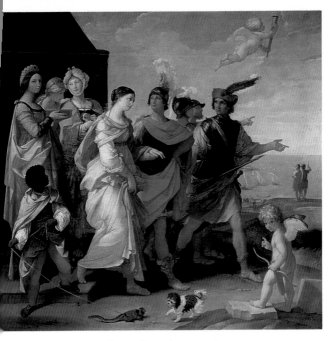

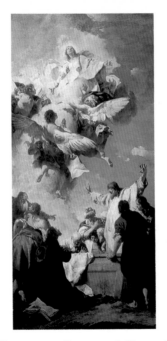

GIAMBATTISTA PIAZZETTA (1683–1754).
The Assumption of the Virgin, 1735.
Canvas, 16 ft. 10¾ in. x 96½ in. (5.15 x 2.45 m).

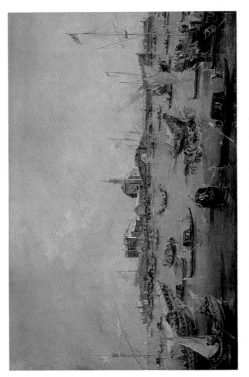

FRANCESCO GUARDI (1712–1792).
The Doge on the Bucentaur at San Nicolò del Lido, c. 1766–70.
Canvas, 26⅜ x 39⅞ in. (67 x 100 cm).

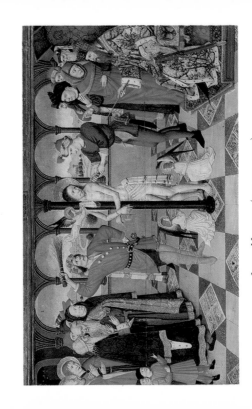

JAIME HUGUET (c. 1415–1492).
The Flagellation of Christ, c. 1450.
Wood, 36¼ x 61⅜ in. (92 x 156 cm).

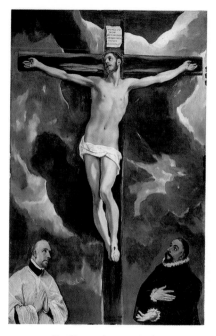

El Greco (1541–1614).
Christ on the Cross Adored by Donors, c. 1585–90.
Canvas, 102⅜ x 67⅜ in. (260 x 171 cm).

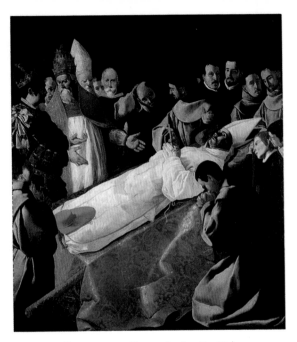

Francisco de Zurbarán (1598–1664).
The Lying-in-State of Saint Bonaventura, 1629.
Canvas, 96½ x 86⅝ in. (245 x 220 cm).

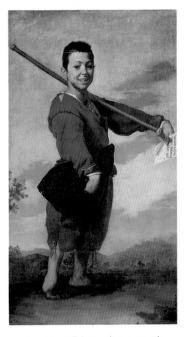

JUSEPE DE RIBERA (1591–1652).
The Club-Footed Boy, 1642.
Canvas, 64⅝ x 35⅝ in. (164 x 93 cm).

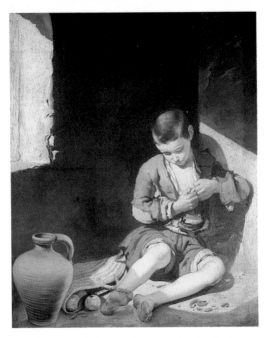

BARTOLOMÉ ESTEBAN MURILLO (1618–1682).
The Young Beggar, c. 1650.
Canvas, 52¾ x 39⅜ in. (134 x 100 cm).

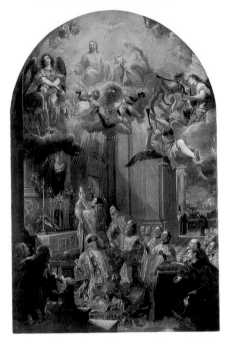

JUAN CARREÑO DE MIRANDA (1614–1685).
Mass for the Founding of the Trinitarian Order, 1666.
Canvas, 16 ft. 4⅞ in. x 10 ft. 10⅜ in. (5 x 3.31 m).

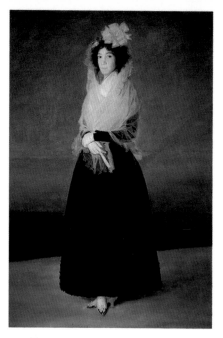

Francisco de Goya (1746–1828).
The Marquesa de la Solana, c. 1793.
Canvas, 71⅜ x 48 in. (181 x 122 cm).

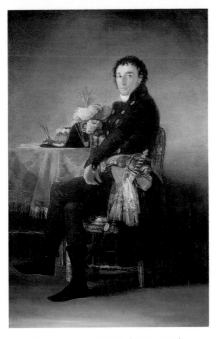

Francisco de Goya (1746–1828).
Ferdinand Guillemardet, 1798.
Canvas, 73¼ x 48¾ in. (186 x 124 cm).

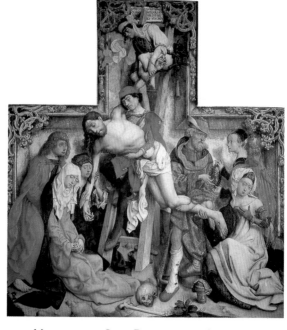

Master of the Saint Bartholomew Altarpiece
(active c. 1480–1510). *The Descent from the Cross*, c. 1501–5.
Wood, 89⅝ x 82⅝ in. (227.5 x 210 cm).

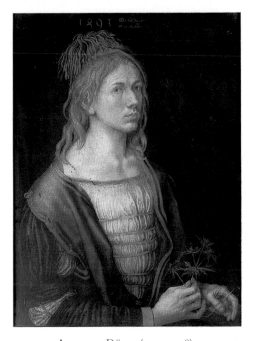

ALBRECHT DÜRER (1471–1528).
Self-Portrait, 1493.
Parchment glued on canvas, 22 x 17⅜ in. (56 x 44 cm).

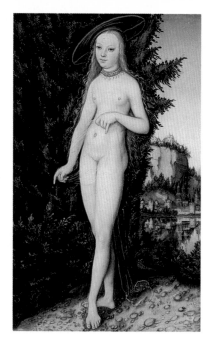

LUCAS CRANACH (1472–1553).
Venus Standing in a Landscape, 1529.
Wood, 15 x 9¾ in. (38 x 25 cm).

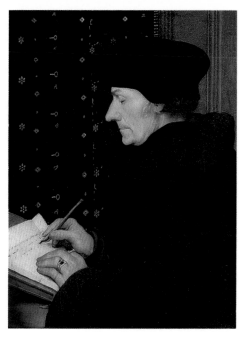

HANS HOLBEIN THE YOUNGER (1497/98–1543).
Erasmus, 1523.
Wood, 16½ x 12⅝ in. (42 x 32 cm).

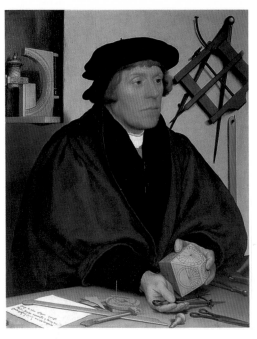

HANS HOLBEIN THE YOUNGER (1497/98–1543).
Nicholas Kratzer, 1528.
Wood, 32⅝ x 26⅜ in. (83 x 67 cm).

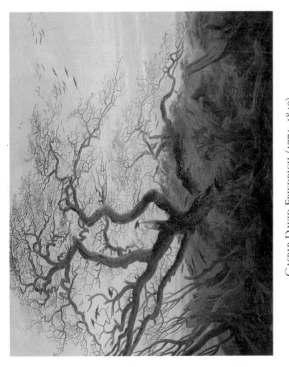

CASPAR DAVID FRIEDRICH (1774–1840).
The Tree of Crows, c. 1822.
Canvas, 23¼ x 29⅛ in. (59 x 74 cm).

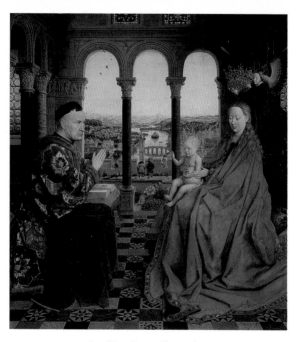

JAN VAN EYCK (d. 1441).
The Madonna of Chancellor Rolin, c. 1435.
Wood, 26 x 24⅜ in. (66 x 62 cm).

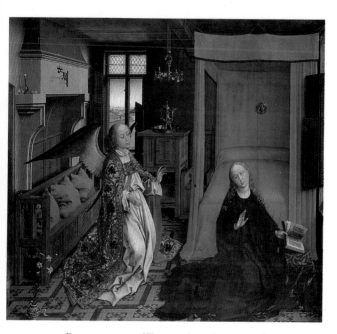

ROGIER VAN DER WEYDEN (1399/1400–1464).
The Annunciation, c. 1435.
Wood, 33⅞ x 36⅝ in. (86 x 93 cm).

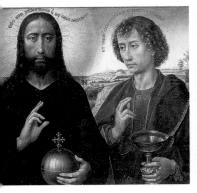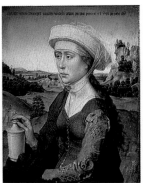

ROGIER VAN DER WEYDEN (1399/1400–1464).
Braque Family Triptych, c. 1450. Left panel: *Saint John the Baptist;*
wood, 16⅛ x 13⅜ in. (41 x 34 cm). Center panel:
Christ Between the Virgin Mary and Saint John the Evangelist;
wood, 16⅛ x 26¾ in. (41 x 68 cm). Right panel: *Saint Mary
Magdalene;* wood, 16⅛ x 13⅜ in. (41 x 34 cm).

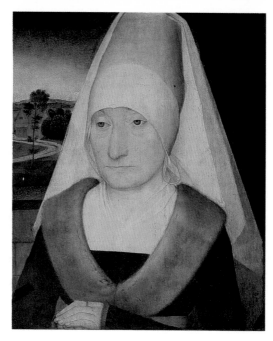

HANS MEMLING (c. 1435–1494).
Portrait of an Old Woman, c. 1470–75.
Wood, 13¾ x 11⅜ in. (35 x 29 cm).

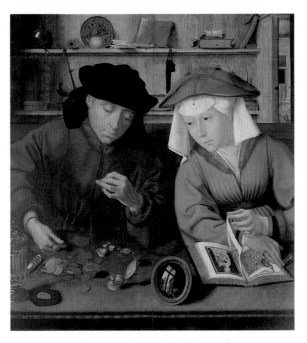

QUENTIN METSYS (1465/66–1530).
The Banker and His Wife, 1514.
Wood, 27⅝ x 26⅜ in. (70 x 67 cm).

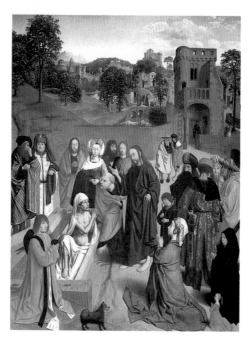

GEERTGEN TOT SINT JANS (1460/65–1488/93).
The Raising of Lazarus, c. 1480.
Wood, 50 x 38¼ in. (127 x 97 cm).

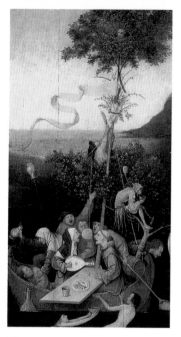

HIERONYMUS BOSCH (c. 1450–1516).
The Ship of Fools, c. 1500(?).
Wood, 22¾ x 12⅝ in. (58 x 32 cm).

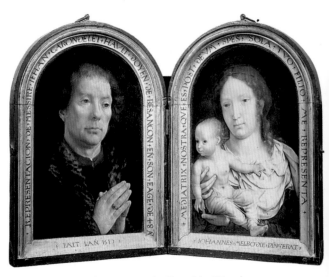

MABUSE (c. 1478–1532). *Carondelet Diptych*, 1517.
Left: *Jean Carondelet*; right: *Virgin and Child*.
Wood, each panel: 16⅝ x 10⅝ in. (42.5 x 27 cm).

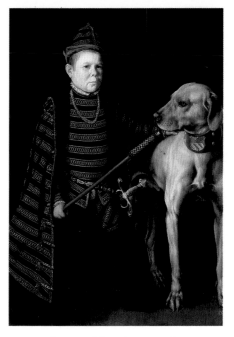

ANTONIO MORO (1517–1576).
Cardinal Granvella's Dwarf, c. 1560.
Wood, 49⅝ x 36¼ in. (126 x 92 cm).

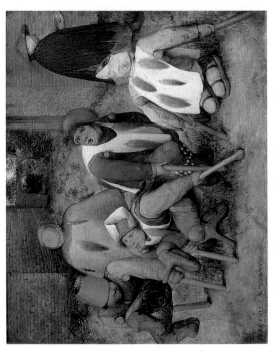

PIETER BRUEGEL THE ELDER (c. 1525–1569).
The Beggars, 1568.
Wood, 7⅞ x 8½ in. (18 x 21.5 cm).

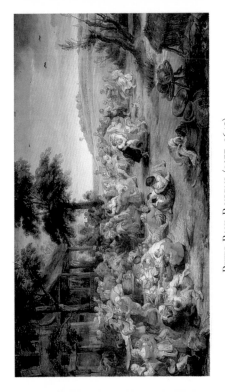

PETER PAUL RUBENS (1577–1640).
The Village Fête, c. 1635–38.
Wood, 58⅝ x 102¾ in. (149 x 261 cm).

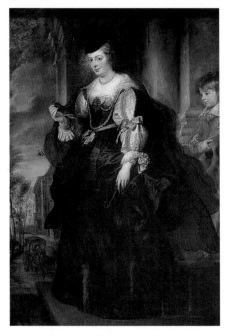

PETER PAUL RUBENS (1577–1640).
Helena Fourment with a Carriage, c. 1639.
Wood, 76¾ x 52 in. (195 x 132 cm).

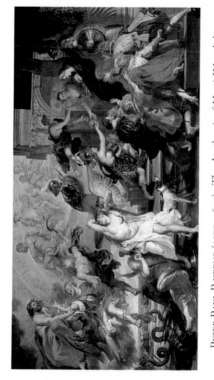

PETER PAUL RUBENS (1577–1640). *The Apotheosis of Henri IV and the Proclamation of the Regency of Marie de Médicis, on May 14, 1610*, c. 1622–24. Canvas, 12 ft. 11⅛ in. x 23 ft. 10¾ in. (3.94 x 7.27 m).

JAN BRUEGEL THE ELDER (1568–1625).
The Battle of Issos, 1602.
Wood, 33⅞ x 53⅛ in. (86 x 135 cm).

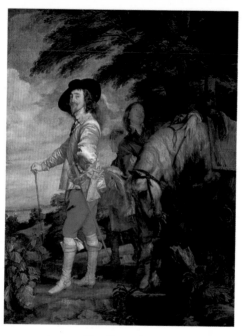

ANTONY VAN DYCK (1599–1641).
Charles I, King of England, at the Hunt, c. 1635.
Canvas, 104⅝ x 81½ in. (266 x 207 cm).

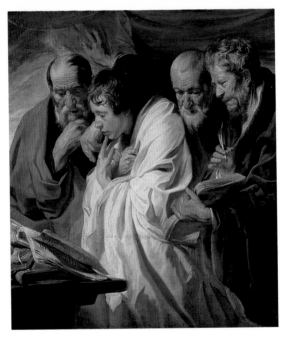

JACOB JORDAENS (1593–1678).
The Four Evangelists, c. 1625.
Canvas, 52¾ x 46½ in. (134 x 118 cm).

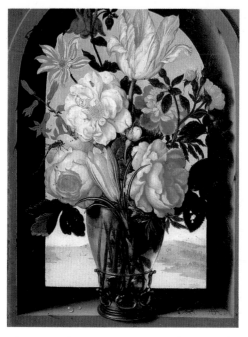

AMBROSIUS BOSSCHAERT THE ELDER (1573–1621).
Bouquet of Flowers in an Arch, c. 1620.
Copper, 9 x 6⅜ in. (23 x 17 cm).

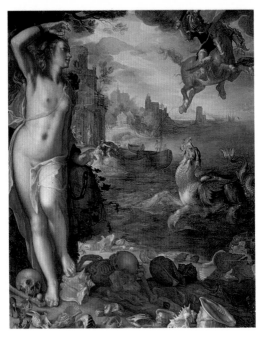

JOACHIM WTEWAEL (1566–1638).
Perseus and Andromeda, 1611.
Canvas, 70⅞ x 59⅛ in. (180 x 150 cm).

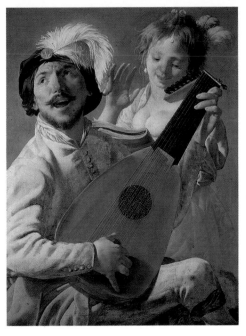

HENDRICK TER BRUGGHEN (1588–1651).
The Duet, 1628.
Canvas, 41⅜ x 32¼ in. (106 x 82 cm).

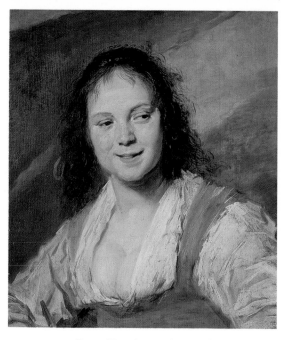

FRANS HALS (c. 1581/85–1666).
The Gypsy Girl, c. 1628–30.
Canvas, 22¾ x 20½ in. (58 x 52 cm).

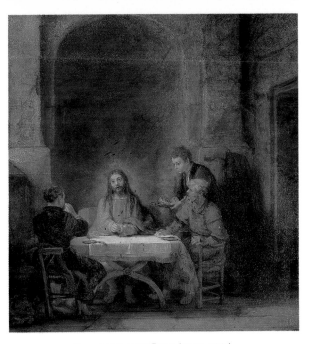

REMBRANDT VAN RIJN (1606–1669).
The Supper at Emmaus, 1648.
Wood, 26¾ x 25⅜ in. (68 x 65 cm).

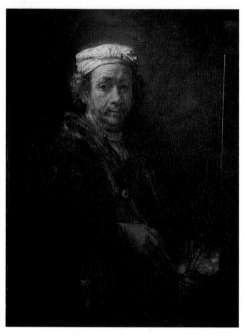

REMBRANDT VAN RIJN (1606–1669).
Self-Portrait in Front of an Easel, 1660.
Canvas, 43¾ x 35⅜ in. (111 x 90 cm).

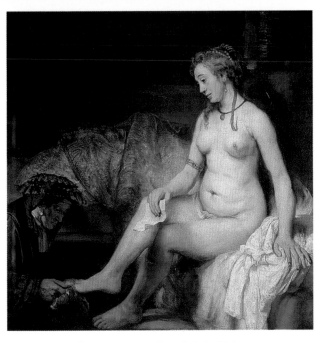

REMBRANDT VAN RIJN (1606–1669).
Bathsheba, 1654.
Canvas, 55⅛ x 55⅞ in. (142 x 142 cm).

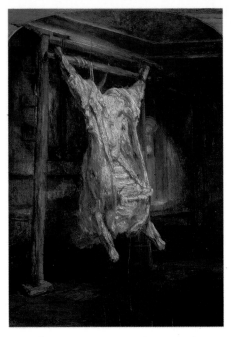

REMBRANDT VAN RIJN (1606–1669).
The Slaughtered Ox, 1655.
Wood, 37 x 27¼ in. (94 x 69 cm).

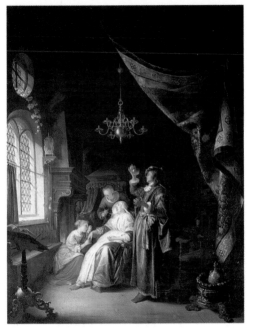

GERRIT DOU (1613–1675).
The Dropsical Woman, 1663.
Wood, 33⅜ x 26⅜ in. (86 x 67.8 cm).

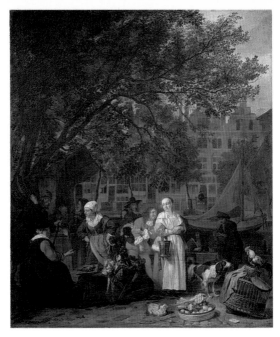

GABRIEL METSU (1629–1667).
The Amsterdam Vegetable Market, c. 1660.
Canvas, 38¼ x 33⅜ in. (97 x 84.5 cm).

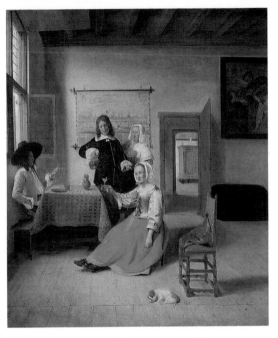

PIETER DE HOOCH (1629–1684).
A Young Woman Drinking, 1658.
Canvas, 27¼ x 23⅜ in. (69 x 60 cm).

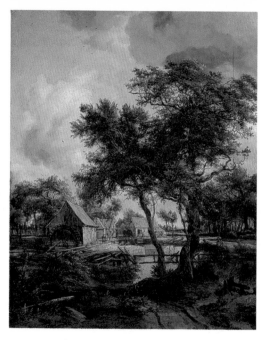

MEINDERT HOBBEMA (1638–1709).
The Water Mill, c. 1660–70(?).
Canvas, 31½ x 26 in. (80 x 66 cm).

Jacob Van Ruisdael (1628/29–1682).
The Ray of Sunlight, c. 1660(?).
Canvas, 32⅜ x 39 in. (83 x 99 cm).

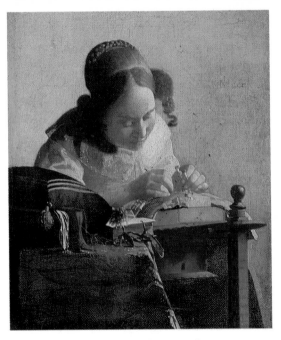

JAN VERMEER (1632–1675).
The Lacemaker, c. 1665.
Canvas on wood, 9⅜ x 8⅜ in. (24 x 21 cm).

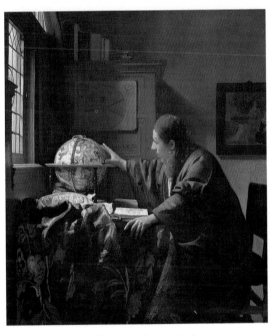

JAN VERMEER (1632–1675).
The Astronomer, c. 1668.
Canvas, 19⅜ x 17⅜ in. (50 x 45 cm).

THOMAS GAINSBOROUGH (1727–1788).
Lady Alston, c. 1760–65.
Canvas, 89 x 66⅛ in. (226 x 168 cm).

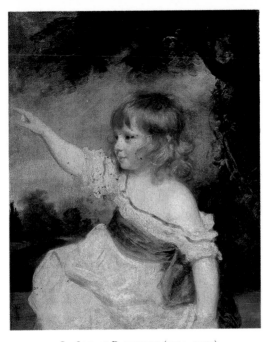

SIR JOSHUA REYNOLDS (1723–1792).
Master Hare, 1788–89.
Canvas, 30⅜ x 24¾ in. (77 x 63 cm).

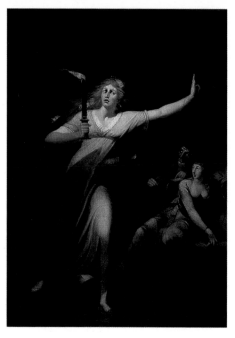

HENRY FUSELI (1741–1825).
Lady Macbeth, 1784.
Canvas, 87 x 63 in. (221 x 160 cm).

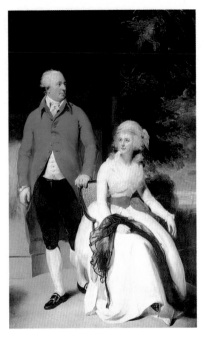

THOMAS LAWRENCE (1769–1830).
Mr. and Mrs. Julius Angerstein, 1792.
Canvas, 99¼ x 63 in. (252 x 160 cm).

JOSEPH MALLORD WILLIAM TURNER (1775–1851).
Landscape with a River and a Bay in the Background, c. 1845.
Canvas, 36⅝ × 48⅜ in. (93 × 123 cm).

DRAWINGS

PARIS WORKSHOP.
Narbonne Ornament, c. 1375.
Black ink on silk, 30½ x 112⅝ in. (77.5 x 286 cm).

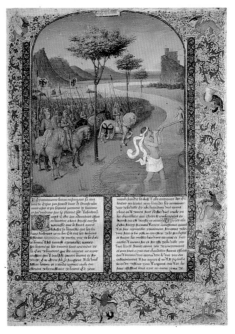

JEAN FOUQUET (c. 1420–1477/81).
Crossing the Rubicon.
Illumination on vellum, 17⅜ x 12¾ in. (44 x 32.5 cm).

JACQUES CALLOT (c. 1592–1635).
Louis XIII and Richelieu at the Siege of Ré.
Sepia wash, black chalk, 13⅜ x 20¾ in. (34 x 52.8 cm).

NICOLAS POUSSIN (1594–1665).
Extreme Unction.
Pen and sepia ink, sepia wash, 9 x 13⅜ in. (23 x 34 cm).

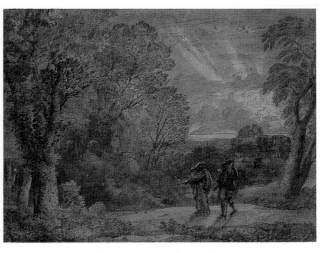

CLAUDE LORRAIN (1602–1682).
The Cumaean Sibyl Leading Aeneas.
Pen and sepia ink, sepia and gray wash with white highlights
on beige paper, 10 x 14 in. (25.3 x 35.5 cm).

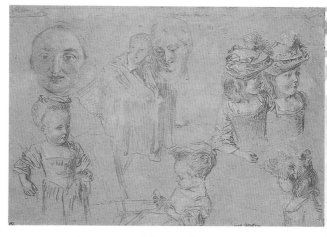

JEAN-ANTOINE WATTEAU (1684–1721).
Pierrot Mask, Five Busts of Young Girls, Draped Man, and Woman's Face. Red chalk with white chalk highlights on buff-colored paper, 10⅝ x 15¾ in. (27.1 x 40 cm).

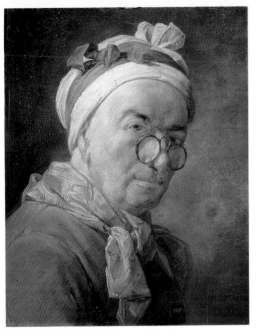

Jean-Baptiste-Siméon Chardin (1699–1779).
Self-Portrait at the Easel, 1771.
Pastel on blue paper over canvas stretcher,
16 x 12¾ in. (40.7 x 32.5 cm).

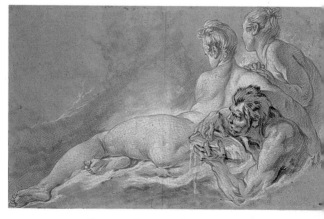

François Boucher (1703-1770).
Naiads and Triton, c. 1753(?).
Black chalk, red chalk, white highlights on beige paper,
11½ x 18½ in. (29.1 x 46.9 cm).

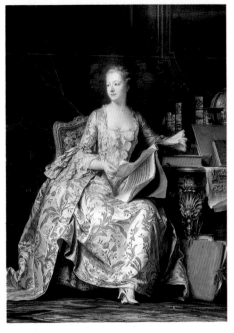

MAURICE QUENTIN DE LA TOUR (1704–1788).
The Marquise de Pompadour, 1752–55.
Pastel on blue-gray paper, 69⅞ x 51½ in. (177.5 x 131 cm).

JEAN-HONORÉ FRAGONARD (1732–1806).
The Pasha.
Sepia wash, 9¾ x 13⅛ in. (24.8 x 33.2 cm).

Jacques-Louis David (1748–1825).
Marie-Antoinette Led to Her Execution.
Pen and sepia ink, 5¾ x 4 in. (14.8 x 10.1 cm).

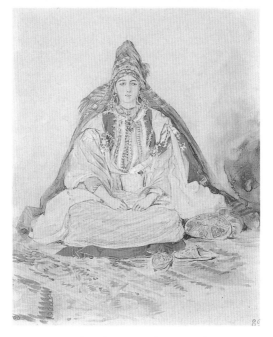

EUGÈNE DELACROIX (1798–1863).
The Jewish Bride of Tangier, 1832. Watercolor over lead pencil
on beige paper, 11⅜ x 9⅜ in. (28.8 x 23.7 cm).

THÉODORE GÉRICAULT (1791–1824). *Leda and the Swan.*
Black crayon, sepia wash, blue watercolor with
white gouache wash and highlights on brown paper,
8½ x 11⅛ in. (21.7 x 28.4 cm).

JEAN-AUGUSTE-DOMINIQUE INGRES (1780–1867).
The Stamaty Family, 1818.
Lead pencil, 18¼ x 14⅝ in. (46.3 x 37.1 cm).

JACOPO BELLINI (d. 1470/71).
The Flagellation of Christ.
Pen and sepia ink on vellum, 16⅝ x 11⅛ in. (42.2 x 28.3 cm).

PISANELLO (before 1395-1455). *Two Horses*.
Pen and brown ink with traces of black chalk,
7⅞ x 6½ in. (20 x 16.6 cm).

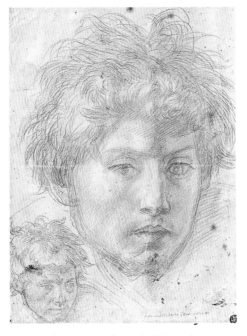

ANDREA DEL SARTO (1486–1530).
Head of a Man in Front View.
Red chalk on beige paper, 13⅛ x 10 in. (33.5 x 25.5 cm).

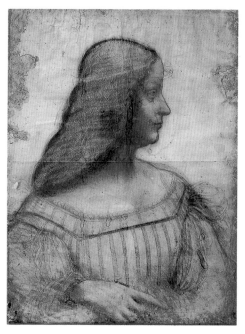

LEONARDO DA VINCI (1452–1519). *Isabelle d'Este.*
Black chalk, red chalk, pastel highlights,
24¾ x 18⅛ in. (63 x 46 cm).

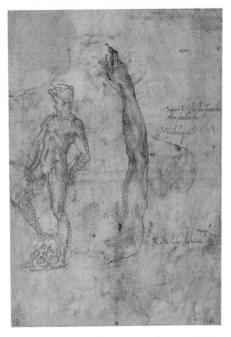

MICHELANGELO BUONARROTI (1475–1564).
Studies of Nudes.
Pen, 10⅜ x 7¼ in. (26.4 x 18.5 cm).

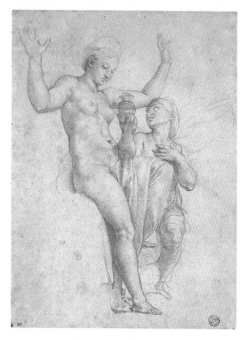

RAPHAEL (1483–1520).
Psyche Offering Venus the Water of the Styx.
Red chalk, 10⅜ x 7⅝ in. (26.3 x 19.3 cm).

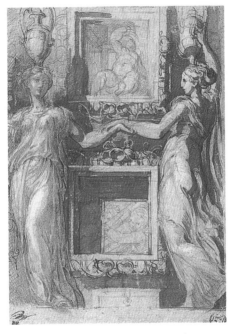

PARMIGIANINO (1503–1540). *Canephores.*
Red chalk, pen and sepia ink, white highlights on beige paper,
7⅝ x 5½ in. (19.6 x 14.1 cm).

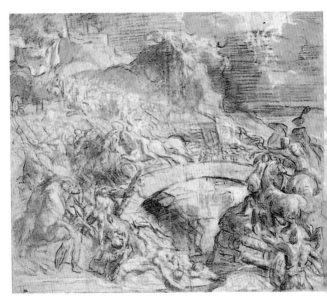

Titian (1488/89-1576). *The Battle of Cadore.*
Black chalk with touches of sepia wash and white highlights
on blue paper, 15¼ x 17⅝ in. (38.3 x 44.6 cm).

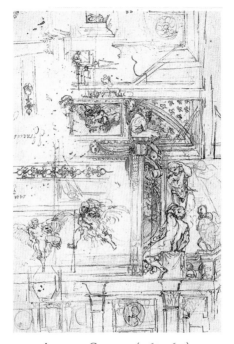

ANNIBALE CARRACCI (1560–1641).
Project for the Farnese Gallery.
Red chalk, pen and sepia ink, 15⅛ x 10⅜ in. (38.6 x 26.4 cm).

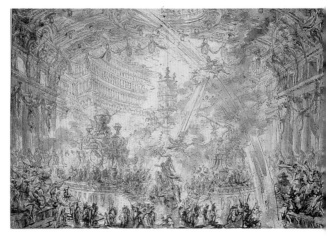

GIOVANNI BATTISTA PIRANESI (1720–1778). *Palace Interior.*
Pen and sepia ink, sepia wash over red-chalk,
20⅛ x 30⅛ in. (51.2 x 76.5 cm).

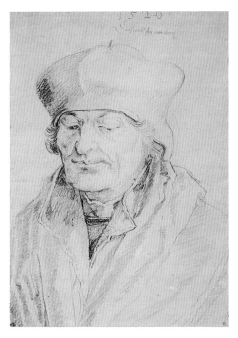

ALBRECHT DÜRER (1471–1528).
Erasmus.
Black chalk, 14⅝ x 10½ in. (37.1 x 26.7 cm).

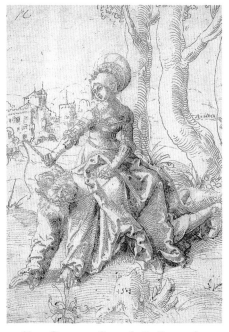

HANS BALDUNG GRIEN (1484/85–1545).
Phyllis and Aristotle.
Pen and black ink, 11⅛ x 8 in. (28.1 x 20.2 cm).

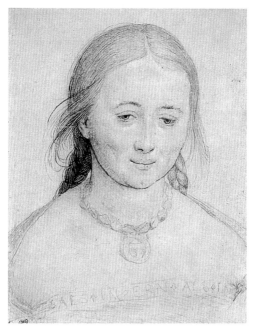

Hans Holbein the Elder (c. 1460/65–1524).
Head of Young Woman. Metalpoint reworked in ink
with chalk highlights on pink-tinted paper,
7⅝ x 6⅛ in. (19.6 x 15.4 cm).

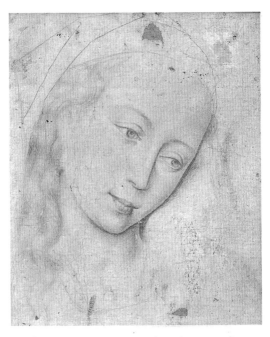

ROGIER VAN DER WEYDEN (1399/1400–1464).
Head of the Virgin. Metalpoint on paper tinted light gray,
5⅛ x 4⅜ in. (12.9 x 11 cm).

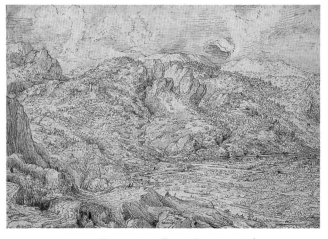

PIETER BRUEGEL THE ELDER (c. 1525–1569).
Landscape of the Alps.
Pen and sepia ink, 9⅜ x 13½ in. (23.6 x 34.3 cm).

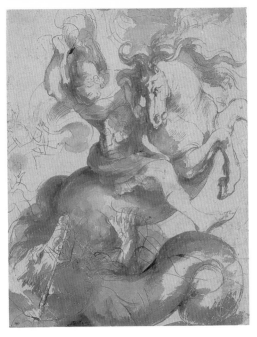

PETER PAUL RUBENS (1577–1640).
Saint George Slaying the Dragon. Pen and brown ink,
brown wash, 13¼ x 10½ in. (33.7 x 26.7 cm).

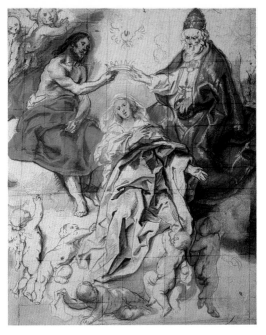

JACOB JORDAENS (1593–1678).
The Coronation of the Virgin by the Holy Trinity.
Watercolor and gouache over black chalk with oil highlights,
18⅜ x 15⅛ in. (46.5 x 38.5 cm).

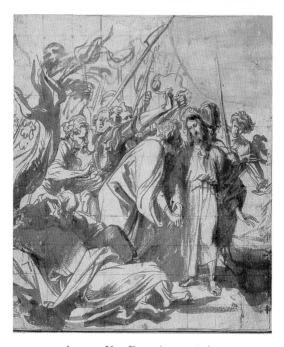

ANTONY VAN DYCK (1599–1641).
Christ's Arrest.
Pen and sepia ink, sepia wash, 9½ x 8¼ in. (24.1 x 20.9 cm).

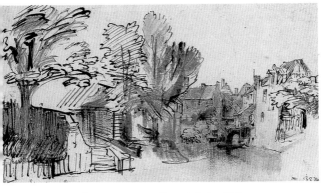

REMBRANDT VAN RIJN (1606–1669).
View of the Singel Canal in Amersfoort.
Pen and sepia ink, sepia wash, 6 x 10⅞ in. (15.3 x 27.7 cm).

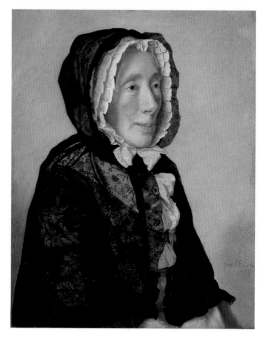

JEAN-ETIENNE LIOTARD (1702–1789).
Madame Tronchin, 1758.
Pastel on wove paper, 24¾ x 19⅝ in. (63 x 50 cm).

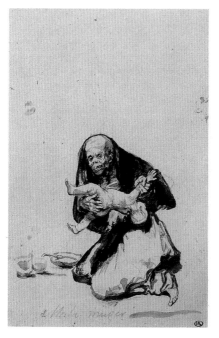

Francisco de Goya (1746–1828).
Evil Woman.
Sepia wash, 8 x 5⅝ in. (20.3 x 14.3 cm).

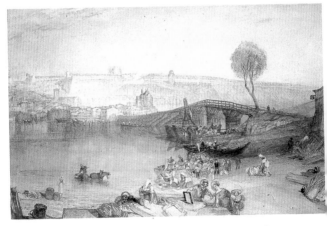

JOSEPH MALLORD WILLIAM TURNER (1775–1851).
View of Saint-Germain-en-Laye and Its Chateau.
Watercolor, 11¾ x 18 in. (29.9 x 45.7 cm).

INDEX OF ILLUSTRATIONS